Modern Scribes and Lettering Artists

Modern Scribes and Lettering Artists

A PENTALIC BOOK

TAPLINGER PUBLISHING COMPANY

New York

First published in the United States in
1980 by
TAPLINGER PUBLISHING CO., INC.
New York, New York

Library of Congress Catalog Card
Number: 80-50362
ISBN 0-8008-5297-4

Contents

Acknowledgements 6

Introduction 7

Calligraphy and lettering 9

Calligraphy and lettering for reproduction 87

Inscriptional lettering 127

Index of calligraphers 157

Calligraphy societies 159

Calligraphy services 160

Acknowledgements

The publishers wish to thank in particular The Society of Scribes &
Illuminators, London for all their patient work and enthusiasm and the
following societies for their co-operation: Calligraphy Space 2001, New
York City; Chicago Calligraphy Collective; Colleagues of Calligraphy, St
Paul, Minnesota; Friends of Calligraphy, San Francisco; Lettering Arts
Guild of Boston; Opulent Order of Practising Scribes, Roswell, New
Mexico; Philadelphia Calligraphers Society; Society for Calligraphy, Los
Angeles; British Columbian Branch of the Society for Italic Handwriting;
Society of Scribes, New York City; The Society for Italic Handwriting,
London; Washington Calligraphers Guild; Western American Branch of
the Society for Italic Handwriting.

Artwork by Robert Boyajian, Tony Di Spigna, Charles Pearce, Mary
Quinault Kossakowski, Marcy Robinson, John Skelton, St Clair Richard,
Patricia Weisberg, Wendy Westover is copyright © 1980 of the
respective artists.

While every effort has been made to correctly credit sources apologies are
made for any omissions.

Introduction

Letters and words are everywhere about us. They direct and inform us, often so unconsciously that we are unaware of their potency and power, recording the loftiest and most banal thoughts of mankind. And in writing we all make our own, a love letter, a signature, a shopping list, sometimes with care and an eye for beauty, sometimes illegibly. Those letters around us, in the street or on the printed page, are all made and designed by someone somewhere. Only occasionally are these made by hand. The dullness and insensitivity of much mechanically produced lettering, and all letters should be gay or sad, exuberant or restrained, or whatever is appropriate to a particular situation, is a sad comment on our times. Yet in so many other ways we live in times that are vigorous and individually vital.

This book is concerned with handmade lettering and calligraphy, some 'one off' pieces of work executed for a particular person or place, some made for reproduction to appear multiplied in many hundreds or thousands in a particular context. That the book has been published is a reflection of the widespread interest in handmade lettering in many parts of the world. More and more people are turning to the sensuous enjoyment of the manipulation of tools and materials in the creation of written and lettered things, physical expressions of intellectual and tactile responses to words and lettershapes.

In this book will be found many and varied examples of lettering in a number of media, parchment, paper, stone, glass, metal and wood, made by a number of craftsmen from many countries, of all levels of experience and expertise. There is work by professional craftsmen and letterers, some of whom have studied and practised their craft for many years, as well as work by enthusiastic amateur craftsmen who, though some may lack the expertise of the professionals, yield nothing in freshness and enthusiasm for their work. This is important because although a professional artist with a skill developed from everyday familiarity with his tools and materials may be capable of producing work with a verve denied the amateur, the amateur unfettered by financial pressures may allow himself to consider work at leisure, its problems and possibilities, and to experiment with techniques and materials in a manner denied the professional.

The reproductions of the work given in this book have been divided into three parts, original lettering and calligraphy, work cut or incised into stone or other material, and lettering made specifically for reproduction. All the work has been carried out since 1976. It must be remembered that each category possesses different qualities and that some of these are bound to be lost in reproduction.

The work made for reproduction, as might be expected, shows best in the book and it is the only work that originally may have been worked upon larger than the size it was designed to appear. It is also the only work that might have been carefully built up, parts added or removed and otherwise altered until judged ready for use. In this way handmade lettering for reproduction can lose something of the qualities of being handmade and present a misleading impression of perfection of finish.

The original calligraphic work loses most in reproduction as the very qualities that are most valued in it cannot be reproduced. The potency of the artist's hand, the actual strokes of pen or brush on skin or paper, will cast a spell over the spectator. The subtlety of the intimate relationship between object and spectator will always differ from person to person according to light and mood, but these can only be enjoyed in front of an original. But then the last is true of any lettered object whether made for public display or private enjoyment.

Much of the work in the book reveals the influence of the broad-edged tool, although some has certainly been made with other instruments and the range of tools and materials now available is far wider than ever before. The book therefore shows in an accessible form a wide variety of works in different media and reveals some of the present preoccupations of a number of lettering artists, their models and modes of expression. The book will provide both enjoyment, and information and, perhaps, inspiration, for although the student will always derive encouragement from contemporary work it should be pointed out that the artists themselves may have used an extensive and varied range of models, from the past as well as the present. The secret behind much of the best work lies not so much on 'how can I do something' but rather on 'what do the words demand', 'what do I want to do' and only then 'how can I do it'. The work in this book will allow you to see something of the recent results of this process and show you that lettering can be an art as well as a craft, its applications as versatile and as variable as the mood or needs and the skill of the artist dictate.

Michael Gullick and Ieuan Rees, 1980

Calligraphy and lettering

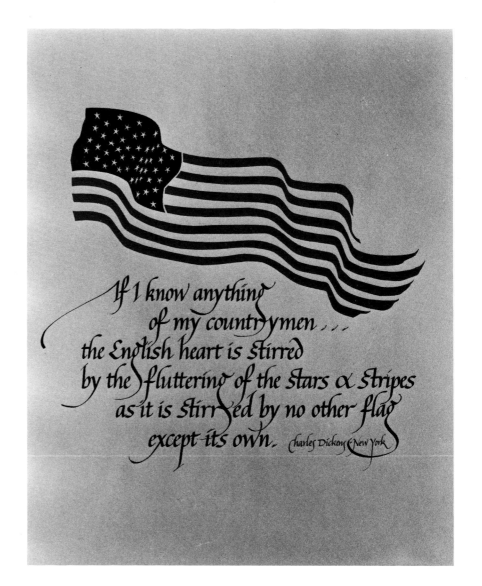

Stanley Knight
'Stars and Stripes'. Blue and red on white paper. Original size 38 × 33 cm (15 × 13 in).

Jean Evans
The Baker in *Hunting of the Snark*, 'Intimate Friends'. The large lettering is written out in purple and silver watercolour, the small lettering in vermilion. All on tan paper. Approximate size of original 20.3 × 61 cm (8 × 24 in).

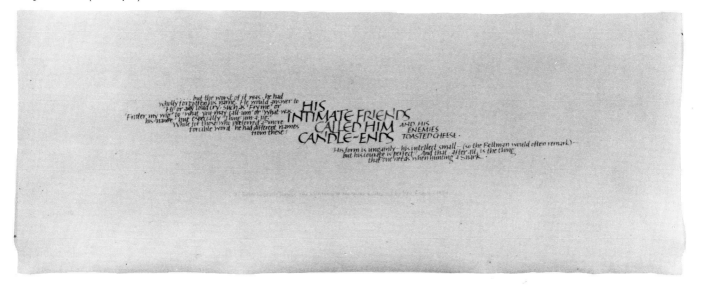

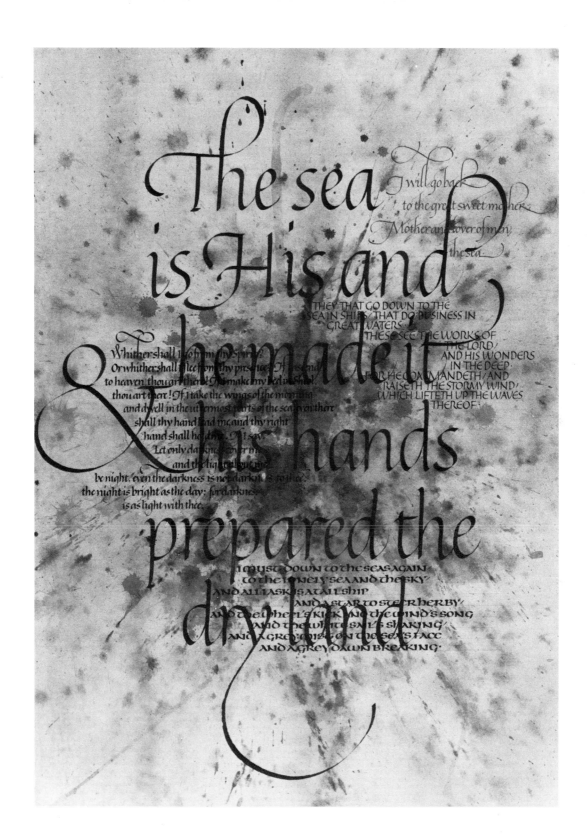

The sea is His and He made it. His hands prepared the dry land.

I will go back to the great sweet mother. Mother and lover of men, the sea.

THEY THAT GO DOWN TO THE SEA IN SHIPS, THAT DO BUSINESS IN GREAT WATERS, THESE SEE THE WORKS OF THE LORD, AND HIS WONDERS IN THE DEEP. FOR HE COMMANDETH, AND RAISETH THE STORMY WIND, WHICH LIFTETH UP THE WAVES THEREOF.

Whither shall I go from thy spirit? Or whither shall I flee from thy presence? If I ascend to heaven, thou art there! If I make my bed in sheol, thou art there! If I take the wings of the morning and dwell in the uttermost parts of the sea, even there shall thy hand lead me, and thy right hand shall hold me. If I say, Let only darkness cover me, and the light about me be night, even the darkness is not dark to thee; the night is bright as the day; for darkness is as light with thee.

I must down to the seas again, to the lonely sea and the sky, and all I ask is a tall ship and a star to steer her by, and the wheel's kick and the wind's song and the white sail's shaking, and a grey mist on the sea's face and a grey dawn breaking.

Charles Pearce
'The Sea'. Written out in coloured inks, stick ink and gouache on handmade paper.

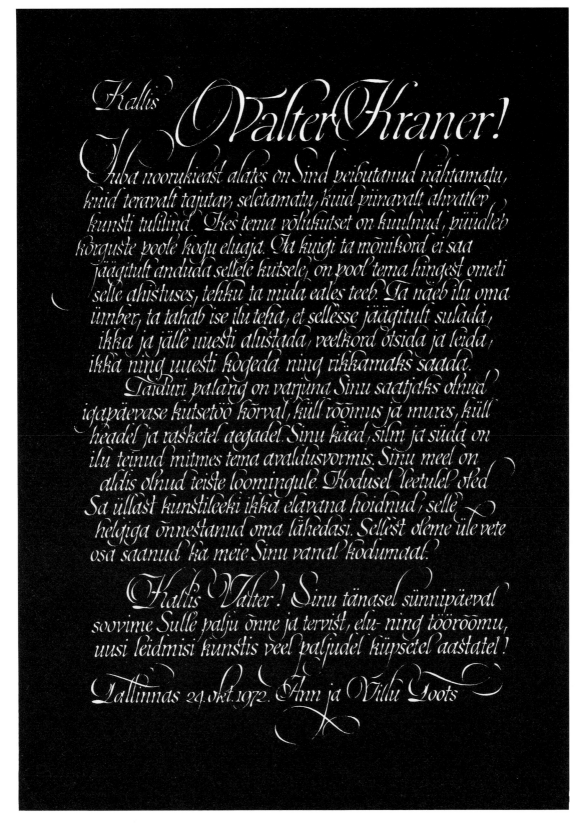

Villu Toots
Address to Valter Kraner. Original size
24.7 × 18 cm (9¾ × 7¼ in).

WE SHALL NOT cease from exploration
And the end of all our exploring
will be
to arrive where we started
& KNOW the place for the first time

Through the unknown,
remembered gate
When the last of earth left to discover
Is that
which was the beginning;

AT THE SOURCE of the longest river
The voice of the hidden waterfall
And the children in the apple tree
Not known,
because not looked for
But heard, half-heard, in the stillness
Between two waves of the sea.

QUICK NOW, HERE, NOW, ALWAYS—
A condition
of complete simplicity
[Costing not less than everything]
And ALL SHALL BE WELL and
All manner of thing shall be well
When the tongues of flame are in-folded
Into the crowned knot of fire
And the fire and the rose are ONE.

from 'Four Quartets' by T S Eliot

Stanley Knight
Framed panel written in various shades of
green and blue on hand-made paper.
Original size 40.6 × 20.3 cm (16 × 8 in).

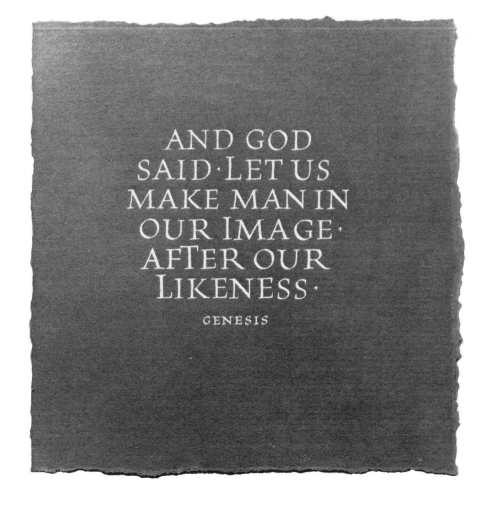

Сваки се успех у стварима састоои од савих совладаних шешкона

ИВО АНДРИЋ

Jovica Veljovic
Lettering. Written out in ink with a
wooden stick on paper. Original size
19 × 38 cm (7½ × 15¼ in).

Jerry Kelly and Julian Waters
Quotation from the book of *Genesis*.
Written out in 23 carat shell gold on blue
Fabriano Roma paper. Original size
19 × 18.7 cm (7½ × 7⅜ in).

AND GOD
SAID·LET US
MAKE MAN IN
OUR IMAGE·
AFTER OUR
LIKENESS·

GENESIS

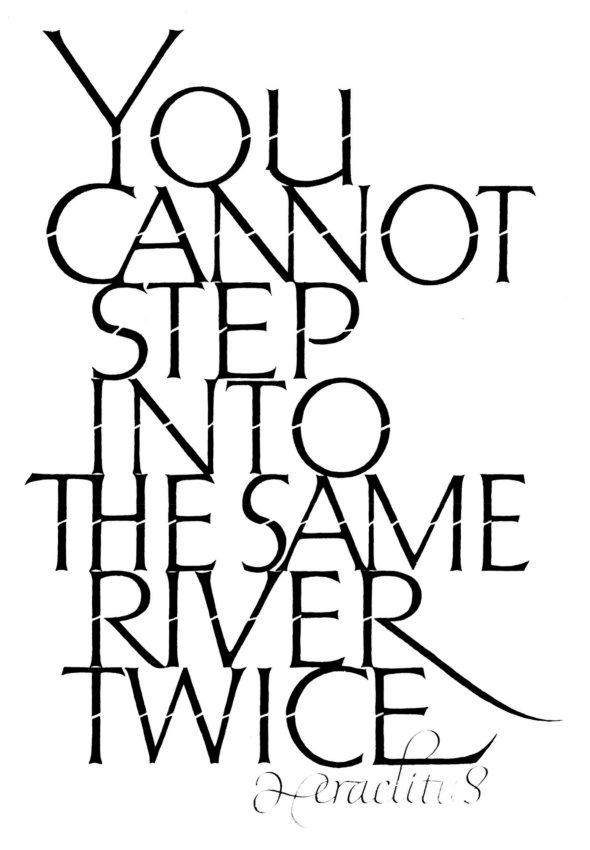

YOU
CANNOT
STEP
INTO
THE SAME
RIVER
TWICE
Heraclitus

William Metzig
Quotation from Heraclitus. Written out
in watercolour and ink on paper. Original
size 36.8 × 27.9 cm (14¼ × 11 in).

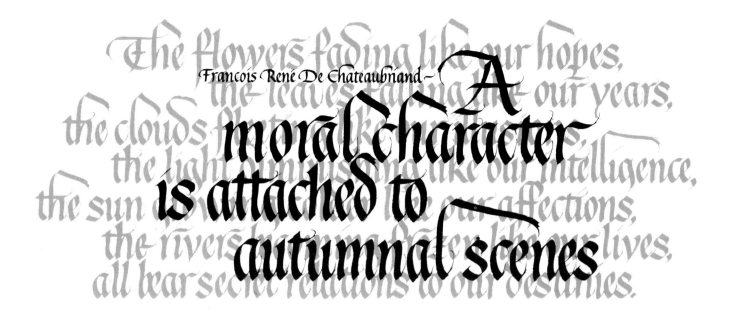

Francois René De Chateaubriand — A moral character is attached to autumnal scenes

Marcy Robinson
Lettering written out in liquid stick ink with a Speedball and William Mitchell nibs. Original size 15.2 × 37 cm (14⅝ × 6 in).

Wendy Westover
Arms of the conservators of Wimbledon and Putney Commons. Written out in gouache, matt gold and India ink on grey Ingres paper. Original size 30.4 × 25.4 cm (12 × 10 in).

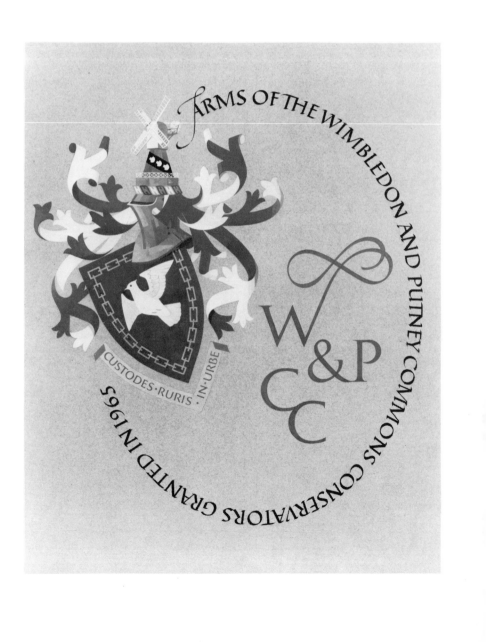

¿En qué reino, en qué SONETO siglo, bajo qué silenciosa
Conjunción de los astros, DEL VINO en qué secreto día
Que el mármol no ha salvado, surgió la valerosa
Y singular idea de inventar la alegría?
Con otoños de oro la inventaron. El vino
Fluye rojo a lo largo de las generaciones
Como el río del tiempo y en el arduo camino
Nos prodiga su música, su fuego y sus leones.
En la noche del júbilo o en la jornada adversa
Exalta la alegría o mitiga el espanto
Y el ditirambo nuevo que este día le canto
Otrora lo cantaron el árabe y el persa.
Vino, enséñame el arte de ver mi propia historia
Como si ésta ya fuera ceniza en la memoria.

Jorge Luis Borges

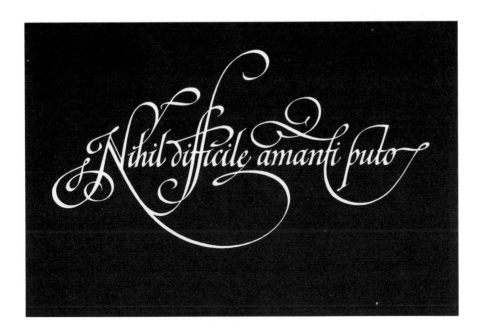

Claude Dieterich
Soneto del Vino a poem by Jorge Luis
Borges. Black India ink on white
watercolour paper. A fountain pen was
used for the text and a steel pen for the
illustration. Overall width of lettering
43 cm ($16\frac{3}{4}$ in).

Jovica Veljovic
'Nihil difficile amanti puto'. Original
size 15 × 22 cm ($5\frac{7}{8}$ × $8\frac{1}{2}$ in).

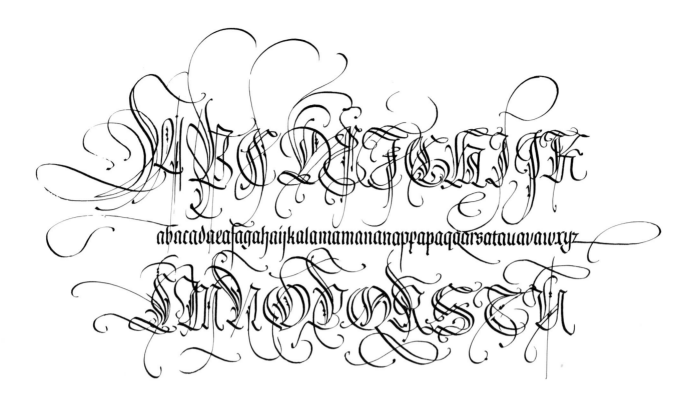

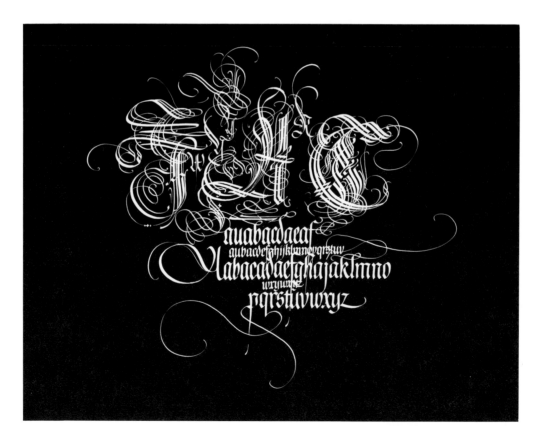

Raphael Boguslav
Two highly decorative calligraphic
alphabets written out in ink on paper.
Original size 35.5 × 43 cm (14 × 17 in).

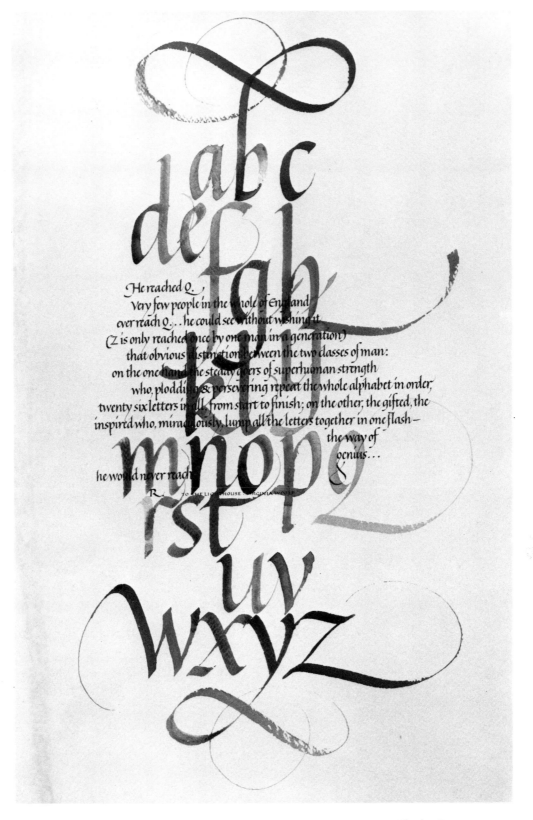

abc
def gh
ij
kl

He reached Q.
Very few people in the whole of England
ever reach Q... he could see without wishing it
(Z is only reached once by one man in a generation)
that obvious distinction between the two classes of man:
on the one hand the steady goers of superhuman strength
who, plodding & persevering repeat the whole alphabet in order,
twenty six letters in all, from start to finish; on the other, the gifted, the
inspired who, miraculously, lump all the letters together in one flash—
the way of
genius...

he would never reach R

TO THE LIGHTHOUSE · VIRGINIA WOOLF

mnopq
rst
uv
wxyz

Charles Pearce
Quotation from *To the lighthouse* by
Virginia Woolf. Written out in
watercolour on Strathmore watercolour
paper.

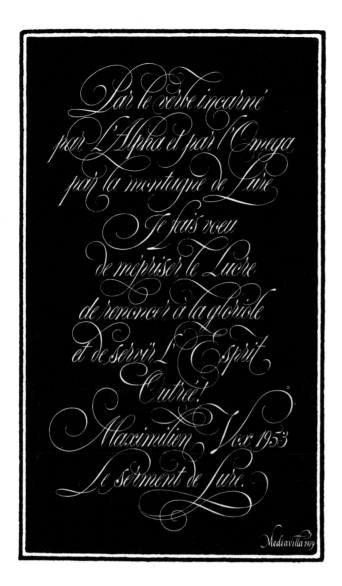

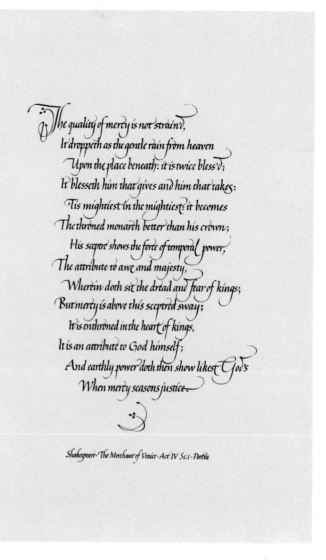

Claude Mediavilla
Calligraphy for Lure's Oath. Original
size 32 × 50 cm (12¾ × 20 in).

Guillermo Rodriguez-Benitez
Quotation from Shakespeare's *The Merchant of Venice*, Act IV Sc I.

Alfred Linz
Quotation from Sigmund Graff. Overall
width of original lettering 22.5 cm (9 in).

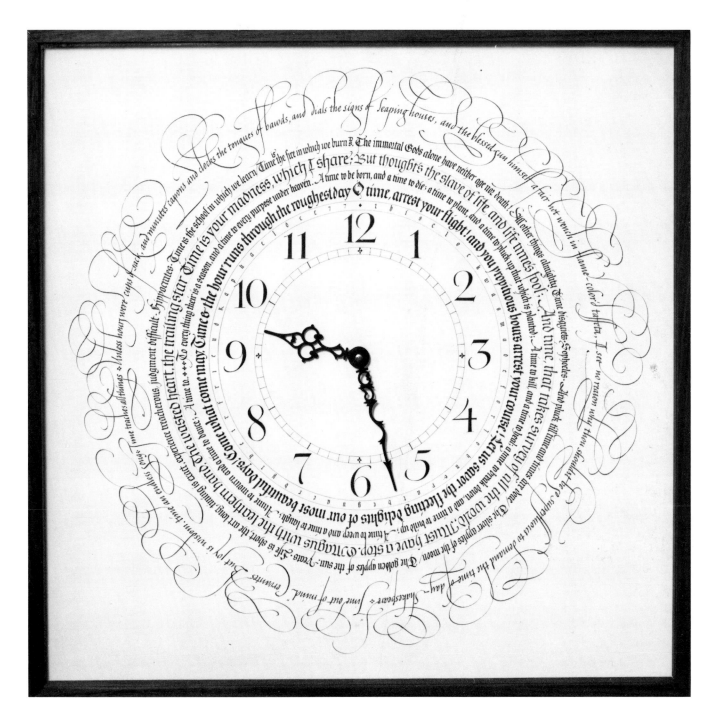

Raphael Boguslav
Clock with walnut frame and battery movement. Original size 48.4 × 48.4 cm (22 × 22 in).
Courtesy, Jon Henauer.

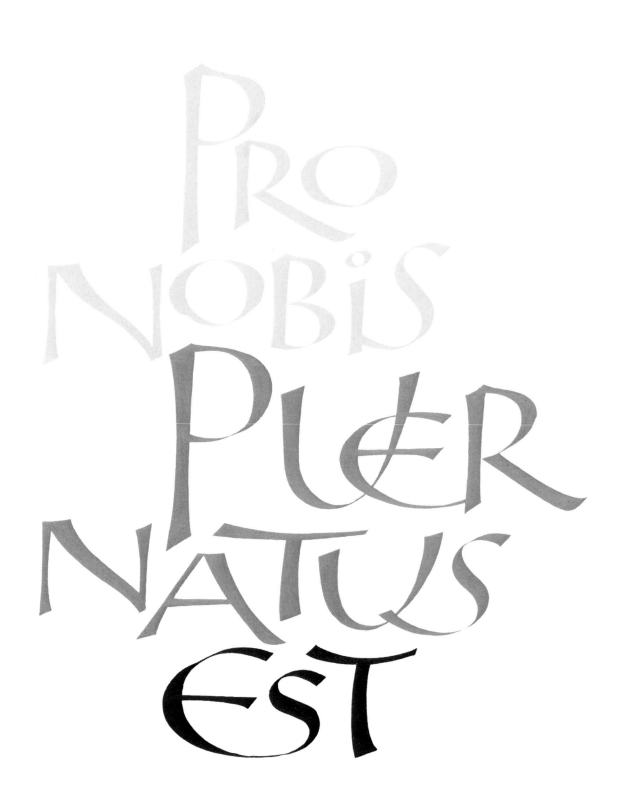

PRO NOBIS PUER NATUS EST

Stanley Knight
Christmas greetings.

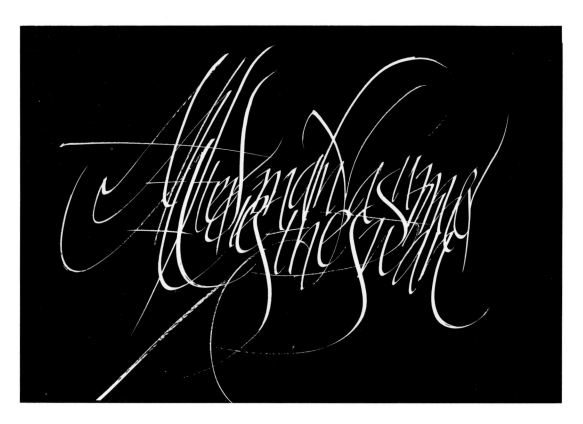

Raphael Boguslav
'After many a summer dies the swan'.
Written out in black ink on white paper.
Original size 45.7 × 61 cm (18 × 24 in).

Alfred Linz
Quotation from Tolstoi. Overall width of
original lettering 15 cm (6 in).

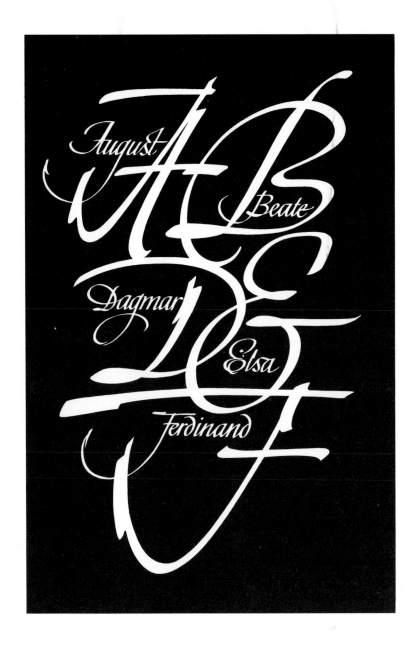

"The man
who has seen
the rising moon
break out
of the clouds at
midnight
has been present
like an
archangel at
the creation of
light and
of the world."
Ralph Waldo Emerson

Villu Toots
A sample page from a book of
Calligraphic Studies. Written out in white
gouache on indigo paper. Original size
23 × 15 cm (9 × 6 in).

James W McFarland
Quotation from Ralph Waldo Emerson.

Jean Evans
Alphabet.

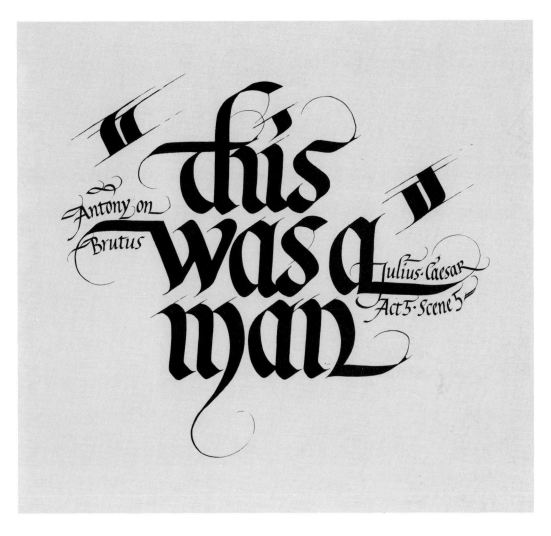

Ieuan Rees
Quotation from Shakespeare written out in black and sepia. Overall width of original lettering 16.5 cm (6½ in).

Patricia Weisberg
Lettering written out on Spunfelt paper. Original size 28 × 35.5 cm (11 × 14 in).

LOVE'S HERALDS SHOULD BE THOUGHTS, WHICH TEN ✳ *Romeo & Juliet* ✳ TIMES FASTER GLIDE THAN THE SUN'S BEAMS

The nature of God is a circle of which the centre is everywhere & the circumference is nowhere.

Ieuan Rees
Demonstration piece done while Artist in Residence at Ysgol Eifionydd, Porthmadog, North Wales. Colour: vermilion. Diameter of original 18.4 cm (7¼ in).

Paul Maurer
Lettering written in watercolour with metal pens. Original size 28 × 43 cm (11 × 17 in).

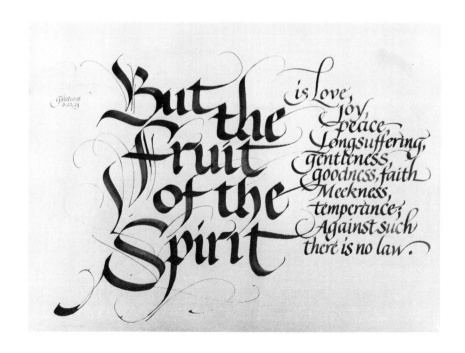

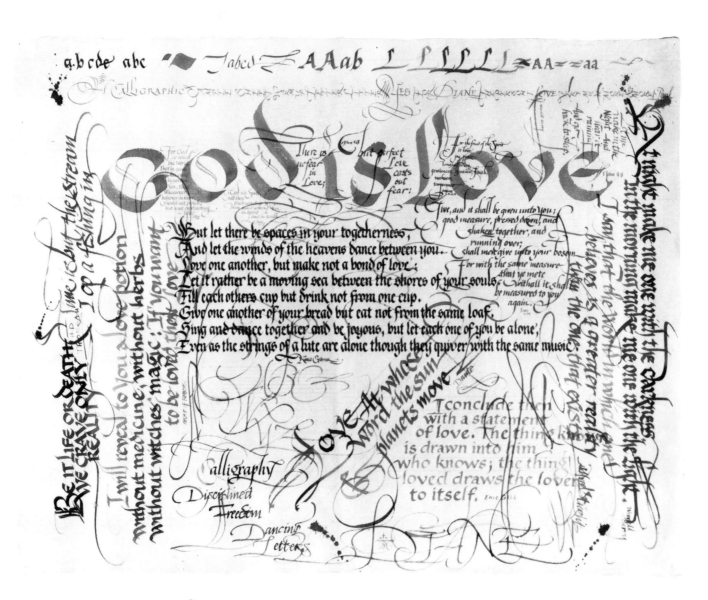

Paul Maurer
Lettering written in watercolour with metal pens and plastic quills. Original size 51 × 76.2 cm (20 × 30 in).

Jeanyee Wong
Two monograms.

Viele Augenblicke
unvermischt
reinen Glückes verdanken
wir der Musik.
Sie läßt uns das Leben
losgelöst von allem
Stofflichen,
im Lichte idealer
Verklärung empfinden.

HERMANN RITTER

Alfred Linz
Quotation from Hermann Ritter. Overall
width of original lettering 17 cm (6¾ in).

Jovica Veljovic
Lettering. Written out in ink with a
wooden stick on paper. Original size
20 × 28 cm (7¾ × 11 in).

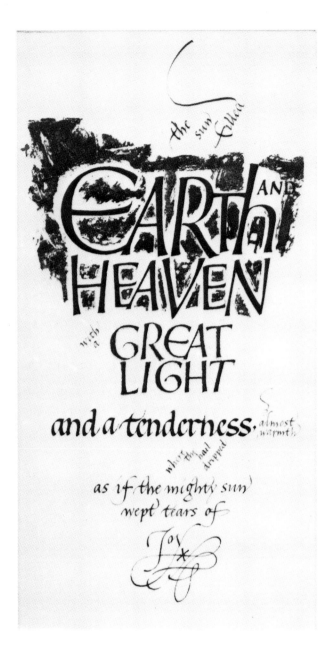

Ann Hechle
Quotation from *March* by Edward
Thomas. An attempt to bring out the
sound shapes of 'Earth and Heaven' and
the intimate quality of the second half of
the stanza. Written out in raised and
burnished gold leaf and burnished gesso,
blue and brown watercolour and stick ink
with quills.

David Williams
1 *Corinthians*, Chapter 15, verses 51–52.
Original size 53.5 × 17.7 cm (21 × 7 in).

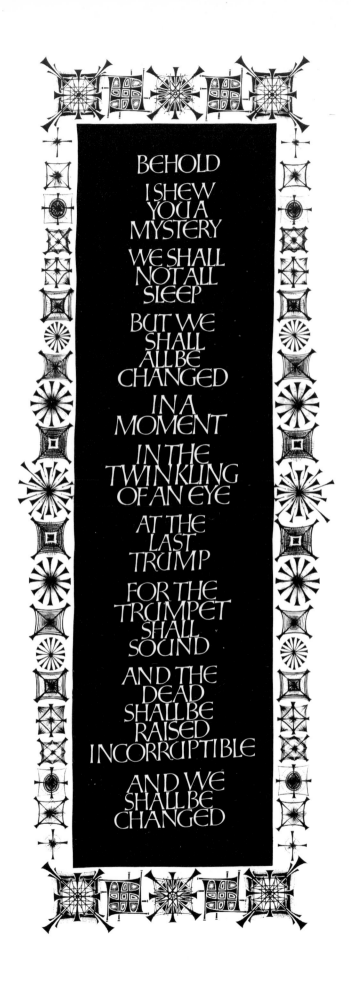

BEHOLD
I SHEW
YOU A
MYSTERY
WE SHALL
NOT ALL
SLEEP
BUT WE
SHALL
ALL BE
CHANGED
IN A
MOMENT
IN THE
TWINKLING
OF AN EYE
AT THE
LAST
TRUMP
FOR THE
TRUMPET
SHALL
SOUND
AND THE
DEAD
SHALL BE
RAISED
INCORRUPTIBLE
AND WE
SHALL BE
CHANGED

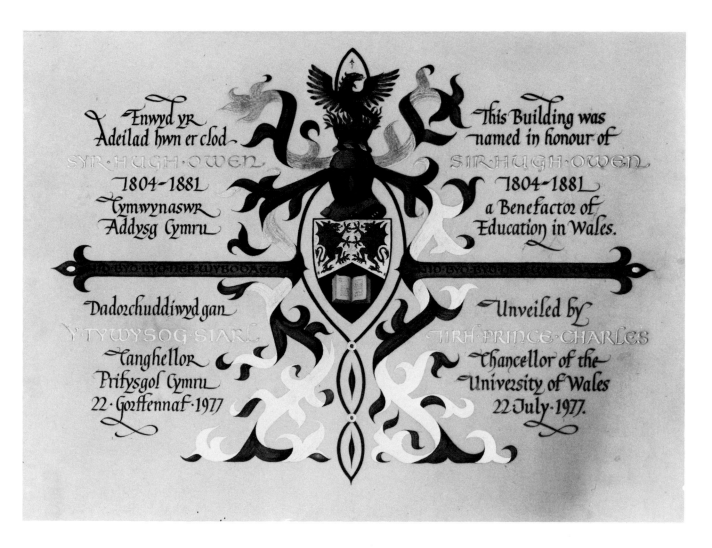

Ieuan Rees
Bilingual gilded vellum panel for 'The
Hugh Owen Building' Aberystwyth.
Original size 53.3 × 76.2 cm (21 × 30 in).

Hella Basu
Sumer. A thirteenth-century poem
from *The Oxford Book of Verse*. Written
out in gouache on charcoal paper.
Original size 50.8 × 76.2 cm (20 × 30 in).

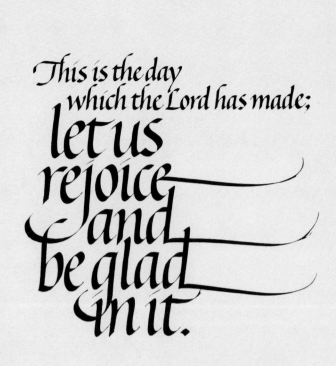

This is the day
which the Lord has made;
let us
rejoice
and
be glad
in it.

PSALM 118:24

Jeanyee Wong
Psalm 118 verse 24. Lettering written out
in black ink on yellow paper. Overall
width of lettering approximately 16 cm
(6¼ in).

I Morris
Quotation written out in orange and
brown gouache on pale apricot ingres
paper. Original size 29.2 × 43 cm
(11½ × 17 in).

YOU CANNOT PROSPER BY DISCOURAGING THRIFT; QUOTATION BY

YOU CANNOT STRENGTHEN THE WEAK BY WEAKENING THE STRONG;

YOU CANNOT HELP THE POOR BY DESTROYING THE RICH; 1865

YOU CANNOT KEEP OUT OF TROUBLE BY SPENDING MORE THAN YOU EARN;

YOU CANNOT BUILD CHARACTER AND COURAGE BY TAKING AWAY

A MAN'S INITIATIVE AND INDEPENDENCE. ABRAHAM LINCOLN

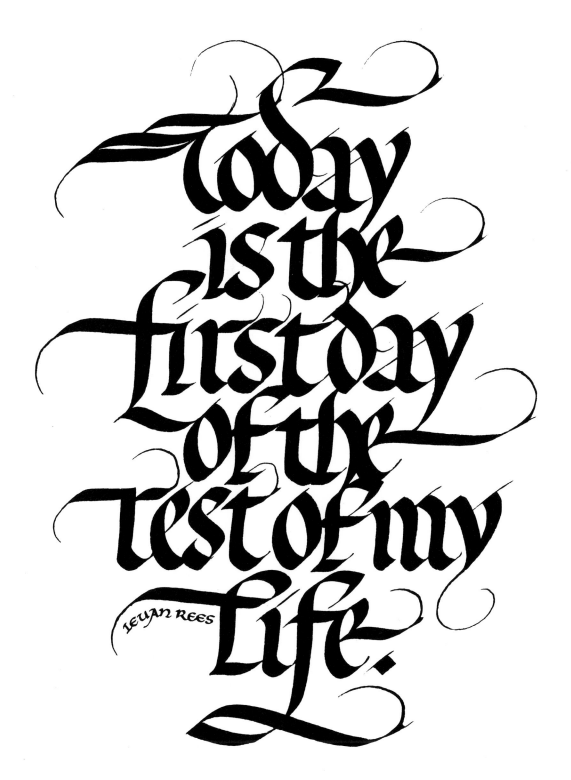

Ieuan Rees
Freely written quotation in black.
Approximate size of original 18 × 14 cm
(7 × 5½ in).

Ieuan Rees
Artwork. Originally gold-blocked on to a
leather bound book. Lettering actual size.

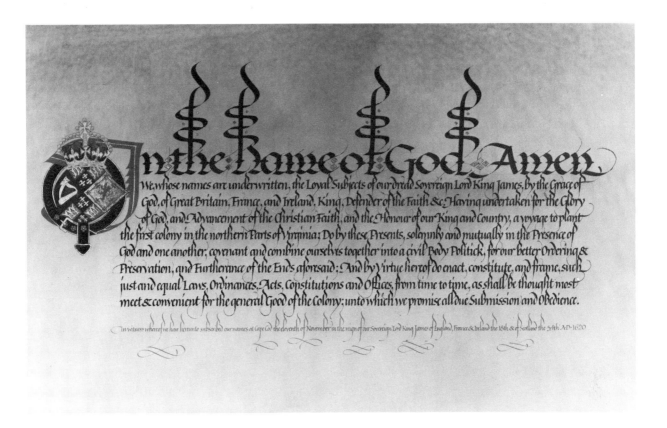

Charles Pearce
The Mayflower Compact. Gold leaf, ink and gouache on hand-made paper. Original size 25.4 × 43 cm (10 × 17 in).

Patricia Weisberg
Quotation from Qadi Ahmad. Written out on Strathmore paper in coloured inks with Bouwsma pen and 2½ pt Mitchell nib. Letters in brown and green, quotation in brown and author's name in green. Original size 35.5 × 43 cm (14 × 17 in).

THE WOODS DECAY,
THE WOODS DECAY AND FALL,
THE VAPOURS
WEEP THEIR BURDEN
TO THE GROUND,
MAN COMES & TILLS THE SOIL
AND LIES BENEATH,
AND AFTER MANY A SUMMER
DIES THE SWAN.

TENNYSON

John Prestianni
Quotation from *Tethonus* by A F
Tennyson. Brush lettering on vellum.
Original size 40 × 58.4 cm (16 × 23 in).

Facing page: 'The Scribe' by St Columba.
The writing is based on the Anglo-Saxon
styles of the 7th and 8th centuries AD.
Written out in ink and illuminated with
watercolour. Original size 76.2 × 53.3 cm
(30 × 21 in).

Bryan Winkworth
Poem *Manasija* by Vasko Popa. Written
out in black ink on white paper. Original
size 28 × 38 cm (11 × 5 in).

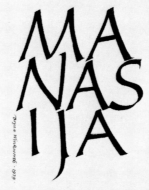

MA NÁS IJA

VASKO POPA

Blue and gold
Last ring of the horizon
Last apple of the sun

OH ZOGRAF
HOW FAR DOES YOUR SIGHT REACH

DO YOU HEAR THE NIGHT HORSEMEN
Allah il ilallah

YOUR BRUSH DOES NOT TREMBLE
YOUR COLOURS ARE NOT AFRAID

THE NIGHT HORSEMEN COME CLOSER
Allah il ilallah

OH ZOGRAF
WHAT DO YOU SEE IN THE NIGHT'S DEPTH

Gold and blue
Last star in the soul
Last infinity in the eye

AH SCRIOBAIDE

The Scribe · by Saint Columba, called Colum-Cille ·

Saint Columba, the great Irish missionary of the sixth century, founded the monastery of Iona off the coast of Scotland. He was born in 521 in the mountains of Donegal, and was baptised by the name Colum, which, in Latin, becomes Columba, or, "the dove." Later generations called him Colum-cille, or, "dove of the church." He had a great reputation as a scribe, so much so that later sources claim he transcribed more than three hundred copies of the gospels in his own hand. It is said that the Book of Durrow, probably written in the eighth century, was copied from a manuscript of Columba's hand.

He was highly educated and belonged to the learned order of Irish poets, the fuild. As a result of his reputation as a poet, a number of poems of much later date have been attributed to him, such as the one transcribed here. In 561, while visiting his old master, Finbar of Moville, he clandestinely copied a codex of the gospels for his own use. Upon discovering this, Finbar, to whom the book belonged, angrily brought the matter before the high king, demanding seizure of the copy. The king ruled against Columba, saying, "to every cow belongs her calf, & to every book its son book," establishing with this pronouncement, possibly for the first time, the law of copyright. According to accounts left us of his life, Columba, in vindication for the judgment that had been rendered against him, instigated the battle of Cul Dreimne, and many lives were lost.

As penance, Columba left Ireland, to "live in exile for Christ." In 563 he established the famous and influential monastery of Iona, where some people think the Book of Kells might have been written, late in the eighth century, from whence, conceivably, it might have been taken to Kells for safety before 806, when the monastery was sacked by Viking invasion. Ireland had only been converted to Christianity a little longer than a century when Columba founded his monastery on Iona. But from the first, Irish monasticism had embraced universal learning, that is, pagan and classical as well as Christian lore, unlike that of the Continent, which, until the beginning of the sixth century conceived itself primarily with learning which related to the spiritual side of monastic life. Ludwig Bieler, in IRELAND, HARBINGER OF THE MIDDLE AGES, says that

Is sith mo chroč on scribann;

in organn mo gless geroll;

sceithis penn gulban caeba

ois noaetha oo oub glegorm.

Bruinnio srm n-ecna noeoairn

as mo laim oegouinn oesmais

ooirio a ois por ouilbin

oo oub in chuillinn chuesglais.

Siuim mo phenn mbec mormach

tar aenach lebar ligoll

cen scor pri selba segoinn

oian seith mo chroč on scribann.

My hand is tired from writing;
my sharp pen is not steady;
the pen, a slender beak, spouts
a dark stream of blue ink.
An unceasing stream of wisdom
pours from my brown hand.
It spills its flow of ink from the
blue-skinned holly over the page.
I send my wet little pen over a
whole fair of lovely books
Without ceasing for the wealth
of great ones, and so my
hand is tired from writing.

it was perfectly natural that the Irish, having become Christians, should be as appreciative of the new learning as they had been of their own traditional lore. This attitude is characteristic of Irish monasticism. The great respect which the Irish had for the written word is manifested most impressively by the fact that they developed a style of handwriting all their own, a national script."

The Irish, or insular, half-uncial as we know it today is regarded as being a development of scripts from antiquity, most likely of a continental half-uncial variety which were brought to Ireland by the earliest missionaries. The Irish & later Anglo-Saxon hands differed in this respect from Continental hands of this period, primary examples of which are the Merovingian, Visigothic, & Beneventan scripts, as these are thought to have been attempts to formalize a mixture of half-uncial and local cursive hands. Bieler says: "Of all the numerous types of Latin script which came into existence during the early middle ages, the Irish script had the longest life and the widest dissemination. All the other ancient national scripts of Europe had to give way to the superior qualities of clarity and practicability of the Caroline minuscule. Even when, with the conquerors and the Continental religious orders, Romanesque and Gothic hands had come into use, the ancient Irish script continued to be employed for the writing of texts in the Irish language, and is so employed to this day."

Perhaps many of the great manuscripts of the seventh & eighth centuries perished in the sweep of Viking invasions which in the ninth century obliterated the Celtic civilization of Northumbria. In looting the rich and important monasteries, the invaders carried off the highly elaborate codices which were frequently decorated & lavishly covered with precious metals & jewels. Among very few others which have been preserved, the Lindisfarne Gospels, the Book of Kells, and the Book of Durrow stand out as masterpieces of scribal art. The motifs and images of the pagan Irish and Anglo-Saxon cultures, established and developed in metalwork and stone carving, were translated by Christian influence into the illumination adorning these books. For us, they are indeed a testament to the vision of their scribes.

Written and designed by John Freeman. Winter 1979

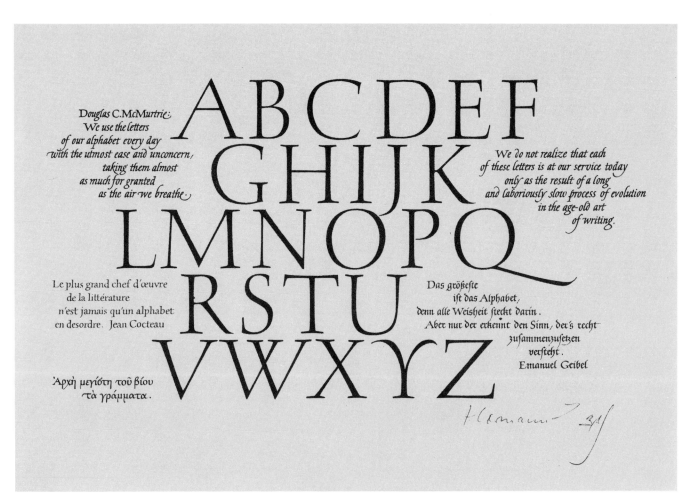

ABCDEF GHIJK LMNOPQ RSTU VWXYZ

Douglas C. McMurtrie:
We use the letters
of our alphabet every day
with the utmost ease and unconcern,
taking them almost
as much for granted
as the air we breathe.

We do not realize that each
of these letters is at our service today
only as the result of a long
and laboriously slow process of evolution
in the age-old art
of writing.

Le plus grand chef d'œuvre
de la littérature
n'est jamais qu'un alphabet
en desordre. Jean Cocteau

Das größefte
ift das Alphabet,
denn alle Weisheit fteckt darin.
Aber nur der erkennt den Sinn, der's recht
zusammenzusetzen
verfteht.
Emanuel Geibel

Ἀρχὴ μεγίστη τοῦ βίου
τὰ γράμματα.

Hermann Zapf
Alphabet with quotations. Commissioned
by Philip Hofer. The Houghton Library,
Cambridge, Massachusetts.

Joan Pilsbury
October by Edward Thomas. Written
out in black, green and burnished gold on
vellum. Green and gold title. Double page
size 30.4 × 35.5 cm (12 × 14 in).

OCTOBER
Edward Thomas.

he green elm with the one great bough of gold
Lets leaves into the grass slip, one by one,—
The short hill grass, the mushrooms small, milk-white
Harebell and scabious and tormentil,
That blackberry and gorse, in dew and sun,
Bow down to; and the wind travels too light
To shake the fallen birch leaves from the fern;
The gossamers wander at their own will.
At heavier steps than birds the squirrels scold.
The rich scene has grown fresh again and new
As Spring and to the touch is not more cool
Than it is warm to the gaze; and now I might
As happy be as earth is beautiful,
Were I some other or with earth could turn
In alternation of violet and rose,
Harebell and snowdrop, at their season due,
And gorse that has no time not to be gay.
But if this be not happiness,—who knows?
Some day I shall think this a happy day,
And this mood by the name of melancholy
Shall no more blackened and obscured be.

MIHI CREDE
RES SEVERA
EST
VERUM
GAUDIUM

Glaube mir,
eine ernste Sache ist eine
wahre Freude

SENECA

Rhythm is in harmony with nature and exists with manifold efficacy and form within all living creatures and within the phenomena of movement which surround us in the regularity of our heart and pulse beats, in our breathing, or in the repetition of forms with like effects in plants of the same kind everywhere we feel the rhythmical law of renewal. As a temporary phenomenon of a rule, in continuous change, we recognise lettering also as rhythmical form.

The flowing movement in writing may be compared to the undulation of waves of water. When we observe waves with their stronger and weaker oscillations, we have a full rhythmical experience. The observation of this movement can give us the completed film, but the single photograph showing only the rigid fragment of one event can never do so. So it is with writing: the writer has the rhythmical experience whilst the beholder of the written matter can only guess at the vivacity of the letter strokes. An attempt to draw the movement of the wave results in the wavy line. By circumscribing the up and down movement of the mountains and valleys of the waves we get the rhythmical experience. But if we draw in such a way that the mountains and valleys in the waves harmonise exactly in their reversed form, then the vivid impulse of the movement is destroyed, and is replaced by a mechanical form.

These explanations as to the nature of rhythm clearly illustrate the immense value of the hand-written letter as against the designed form, for no designed form or type-set line can bear comparison in rhythmical strength with the aspect of the written line. Though, to be sure, we notice in type-set letters a certain harmonious effect, given by the proportional balance of spaces, yet the rigid repetitive effect of absolutely equal characters cannot give to the whole appearance the liveliness of rhythmical undulations. Just as in the fine arts, spontaneity appeals to us more strongly than the composition which is deliberately constructed, so lettering written freely with feeling takes precedence over any designed form of lettering.

WALTER KÄCH · RHYTHM IN LETTERING

Werner Schneider
Two pieces of calligraphy on Fabriano
paper. Original size 48.2 × 66 cm
(19½ × 26 in).

Aabcdefghijklm

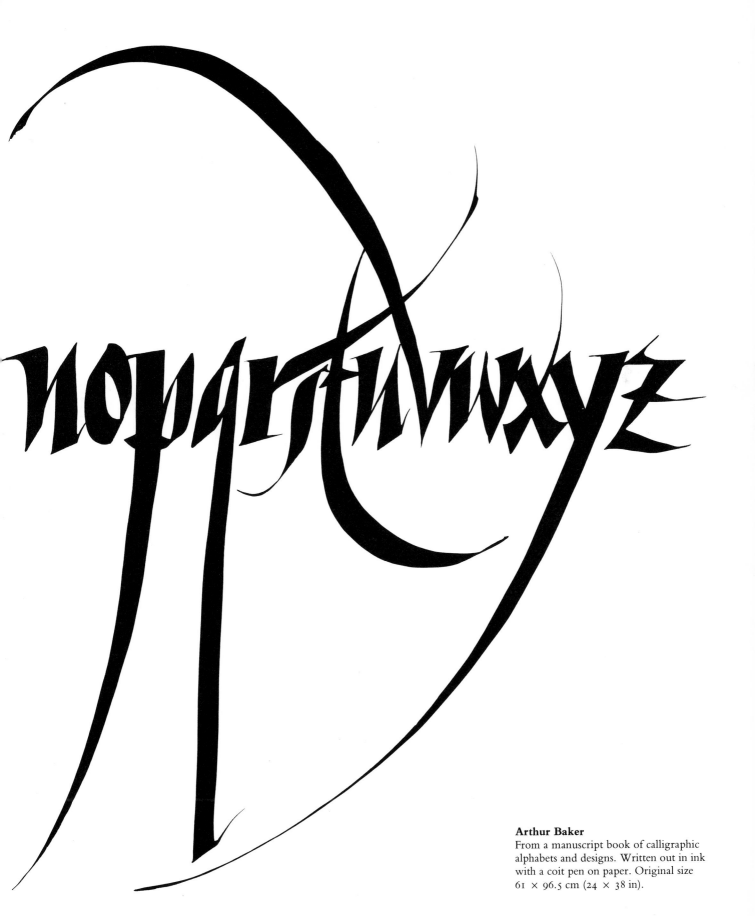

Arthur Baker
From a manuscript book of calligraphic
alphabets and designs. Written out in ink
with a coit pen on paper. Original size
61 × 96.5 cm (24 × 38 in).

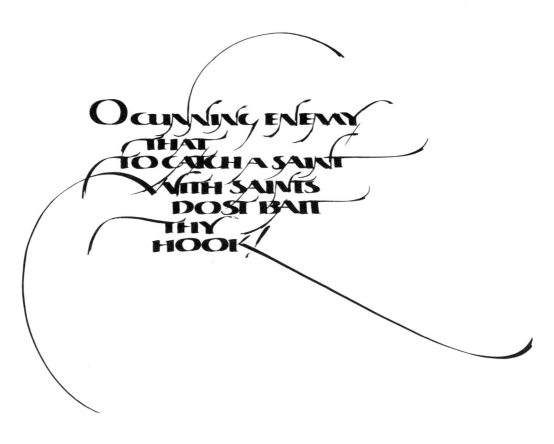

O cunning enemy
that
to catch a saint
with saints
dost bait
thy
hook!

Angelo in Measure for Measure, act 2, scene 2

Nancy Culmone
Lettering written out in ink with a
William Mitchell and automatic pen on
paper. Overall width of lettering in
original 18.5 cm (7¼ in).

John Woodcock
Brush drawn alphabet. Coloured inks and
resist on handmade paper. Approximate
size of original 38 × 51 cm (15 × 20 in).

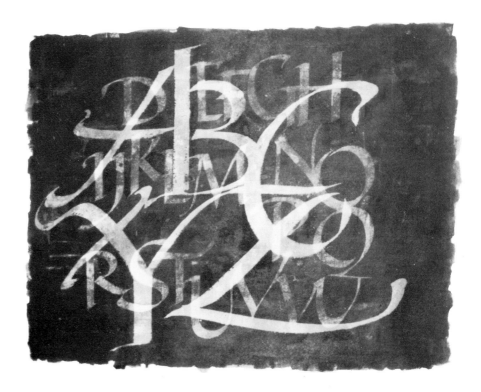

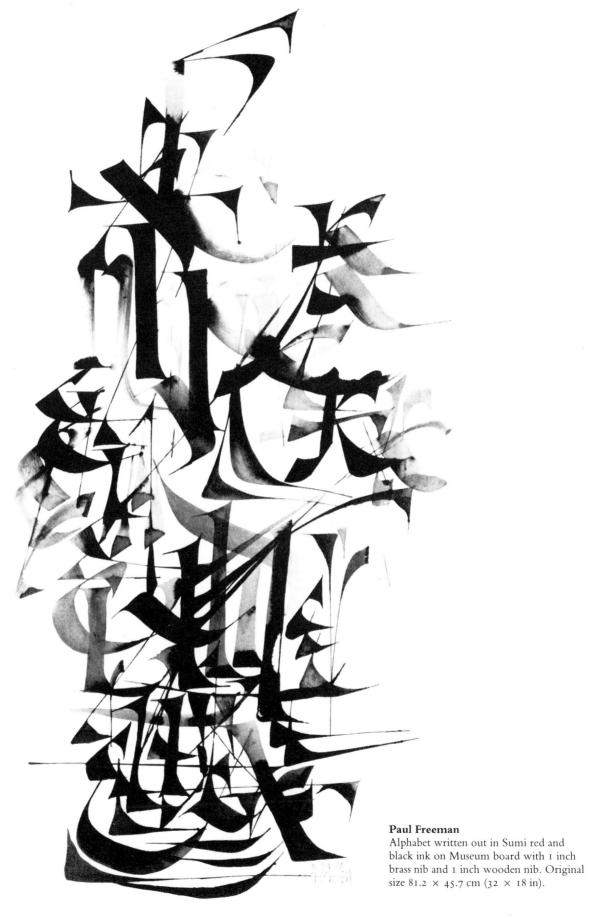

Paul Freeman
Alphabet written out in Sumi red and
black ink on Museum board with 1 inch
brass nib and 1 inch wooden nib. Original
size 81.2 × 45.7 cm (32 × 18 in).

43

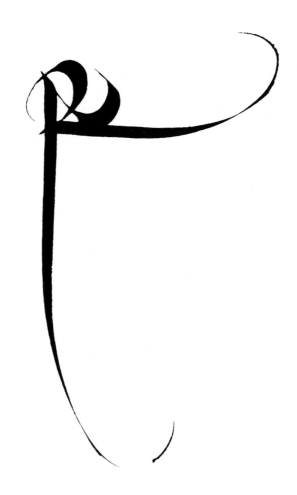

Nancy Culmone
Lettering written in ink with a Speedball
pen on paper.

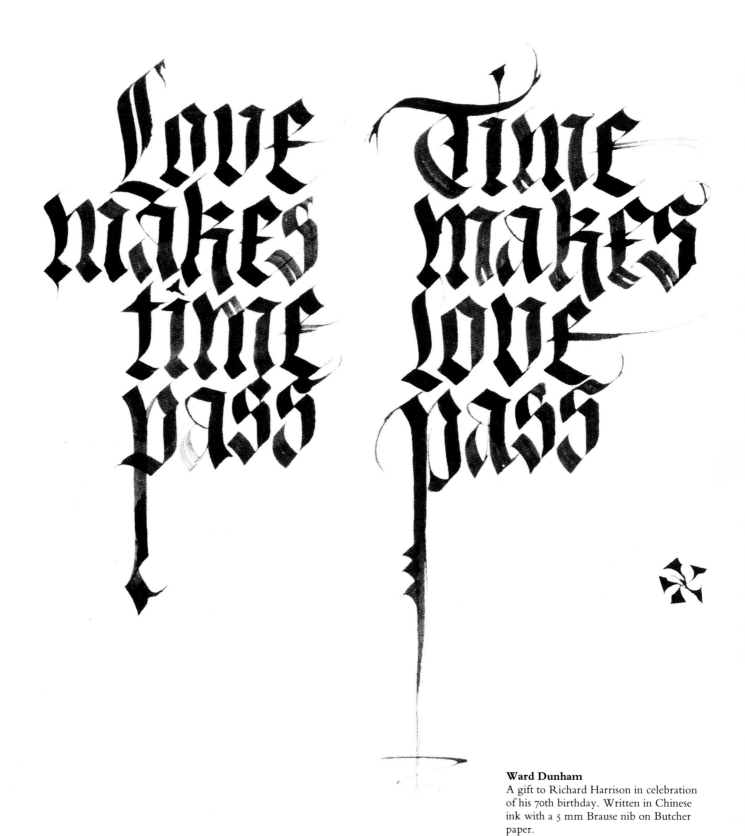

Ward Dunham
A gift to Richard Harrison in celebration of his 70th birthday. Written in Chinese ink with a 5 mm Brause nib on Butcher paper.

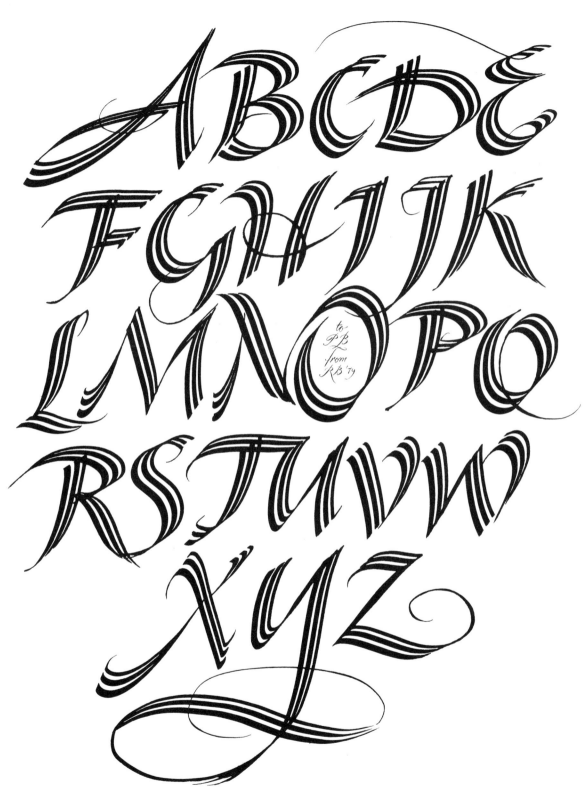

Robert Boyajian
Freely written alphabet. Written out in
sepia and black India ink mixed, with
Lozada brass pen on Hammermill Bond.
Original size 43 × 35.5 cm (17 × 14 in).

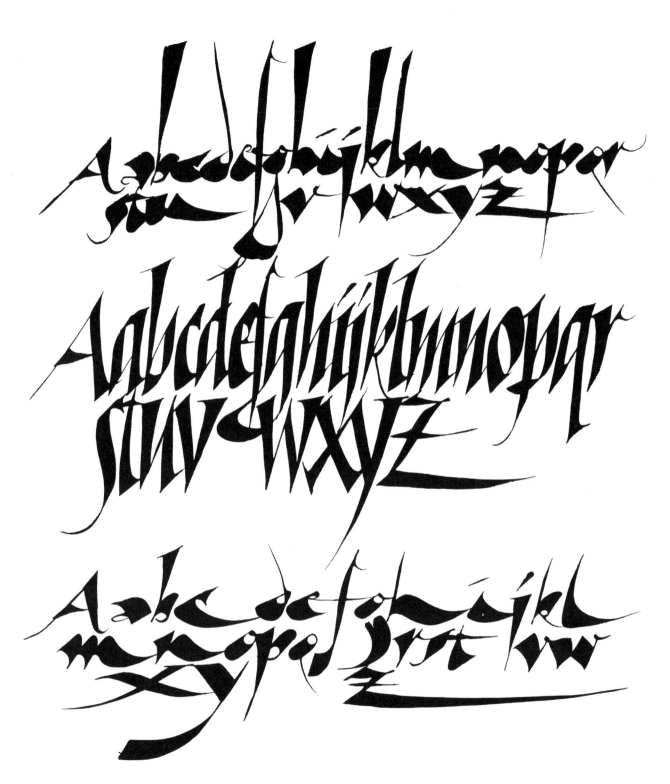

Arthur Baker
Three pen manipulated alphabets.

Oigo decir
que los amantes del vino serán condenados. No hay verdades comprobadas, pero hay mentiras
evidentes. Si los amantes del vino y del amor van al Infierno, vacío
debe estar el Paraíso.

Omar Khayyam

Claude Dieterich
A poem by Omar Khayyam. The initial
was written in red India ink with reed.
The text in black India ink with fountain
pen. Overall width of lettering 52.7 cm
(20½ in).

Jerry Kelly
Passage from the *Anatomy of
Destructiveness* by Erich Fromm. Written
out in blue and red watercolour, asterisks
in black, on Honeysuckle Canson Mi-
tentes paper. Original size
43 × 35.5 cm (17 × 14 in).

Erich Fromm * Today, when almost
everything is made by machines, we notice
little pleasure in skill except perhaps the
pleasure people experience with
hobbies like carpentry or the fascination
of the average person when he can watch a
goldsmith or weaver at his work; perhaps
the fascination with a performing
violinist is not only caused by
the beauty of the music he produces
but by the display of
his skill * from 'the anatomy of human
destructiveness' 1973

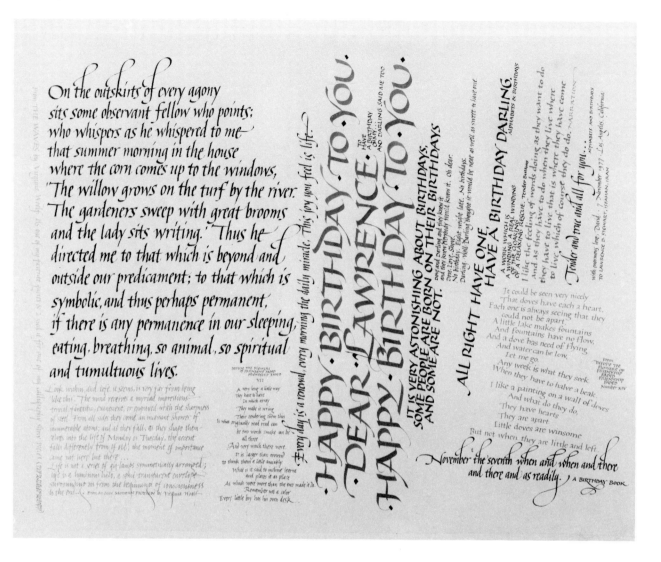

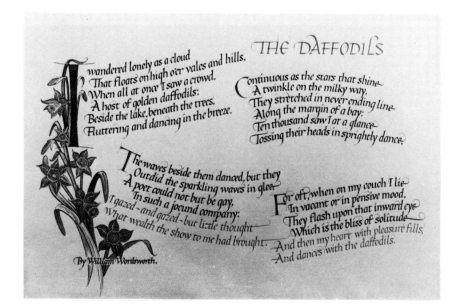

David Mekelburg
A spontaneous unplanned birthday greeting composed of quotations from the works of Gertrude Stein and Virginia Woolf. Written out on Bodleian mould-made paper in black Chinese stick ink, vermilion Japanese Sumi ink, and light blue and dark green gouache, with Brause nibs and turkey quills. Original size 52 × 71 cm (20½ × 28 in).

Nancy Winters
The Daffodils by William Wordsworth. Original size 25.5 × 47 cm (10 × 16 in).

IT IS FORTUNE NOT WISDOM THAT RULES A MAN'S LIFE
CICERO

Stuart Barrie
Quotation from Cicero. Original size framed 38 × 25.4 cm (15 × 10 in).

Anne Benedict
Quotation from W B Yeats. Original size 24 × 18.7 cm (9½ × 7⅜ in).

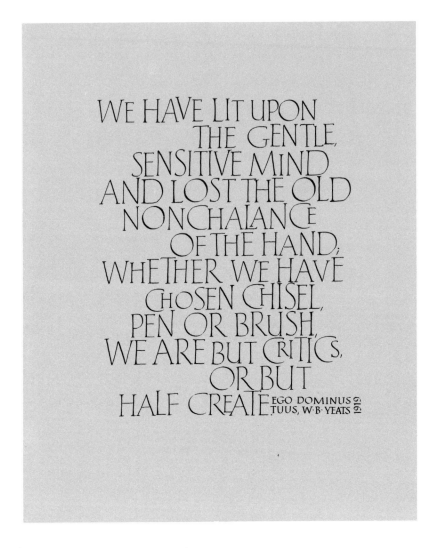

WE HAVE LIT UPON THE GENTLE, SENSITIVE MIND AND LOST THE OLD NONCHALANCE OF THE HAND; WHETHER WE HAVE CHOSEN CHISEL, PEN OR BRUSH, WE ARE BUT CRITICS, OR BUT HALF CREATE EGO DOMINUS TUUS, W·B·YEATS 1919

RUDOLF KO.CH

The following excerpt was written by Fritz Kredel, one
of Koch's finest students. Koch and Kredel collaborated
on many projects in the Offenbach Workshop. This
paragraph is from the introduction to the 1976 reprint
of Das ABC Büchlein by Koch.

* The symbol Koch used in his Offenbach Workshop

Koch's desire to be an educator was paramount. He
wrote a friend "I am nothing but an educator. Of course,
I do not want to educate calligraphers, but human
beings." The human relationship was more important to him
than the work. His first concern was helping his students
to improve themselves, to realize their greatest
potentials. To achieve this, he realized he must set an example,
and for that he was totally qualified. His reliability
and loyalty were irreproachable, his character was
noble. In financial matters a handshake or a verbal agree-
ment was all that was ever necessary. ¶ He was
what I call a real man!

Jerry Kelly
Excerpt from the introduction to the 1976
reprint of *DAS ABC Büchlein* by Rudolf
Koch.

This question is one that only a very old man asks. My benefactor told me about it once when I was young, and my blood was too vigorous for me to understand it. Now I do understand it. I will tell you what it is: Does this path have a heart? All paths are the same: they lead nowhere. They are paths going through the bush, or into the bush. In my own life I could say I have traversed long, long paths, but I am not anywhere. My benefactor's question has meaning now. Does this path have a heart? If it does, the path is good; if it doesn't, it is of no use. Both paths lead nowhere; but one has a heart, the other doesn't. One makes for a joyful journey; as long as you follow it, you are one with it. The other will make you curse your life. One makes you strong; the other weakens you.

FOR ME
THERE IS ONLY
THE TRAVELING
ON PATHS
THAT HAVE
HEART,
ON ANY PATH
THAT MAY
HAVE HEART.
THERE
I TRAVEL AND
THE ONLY
WORTHWHILE
CHALLENGE
IS TO TRAVERSE
ITS FULL LENGTH.
AND THERE
I TRAVEL
LOOKING,
LOOKING
BREATHLESSLY.

CARLOS CASTANEDA:
The Teachings of Don Juan
Written out by David Mekelburg
for Neenie Billawala

David Mekelburg
A passage from *The Teachings of Don Juan* by Carlos Castaneda. Written out with Brause nibs on BFK Rives paper. The small italic writing was done in black Chinese stick ink, the large capitals in Indian red designer's gouache, and the credit lines in grey designer's gouache. Original size 66 × 51 cm (26 × 20 in).

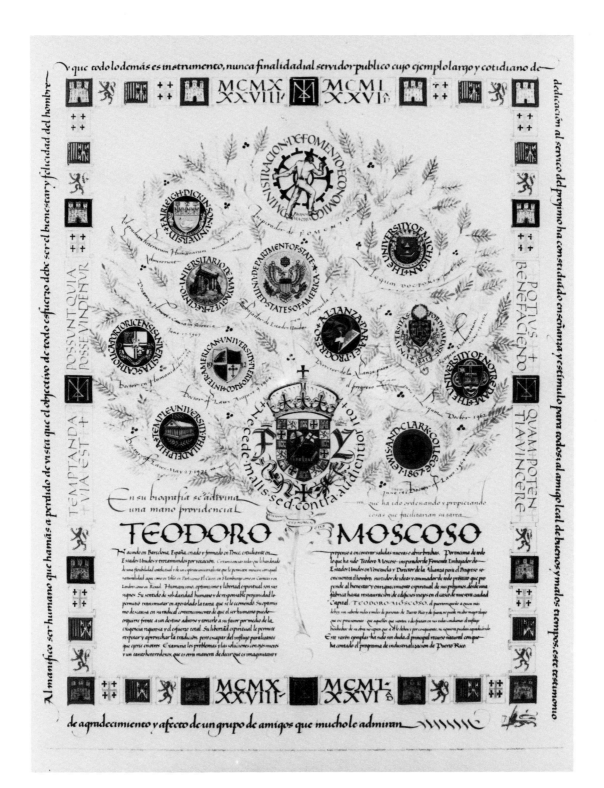

Donald Jackson
Presentation panel to commemorate the public service of Teodoro Moscoso. Written out on vellum in stick ink and pigments, with gesso, gum ammoniac and powder gilding with quills. Original size 66 × 51 cm (26 × 20 in).
Courtesy, Teodoro Moscoso.

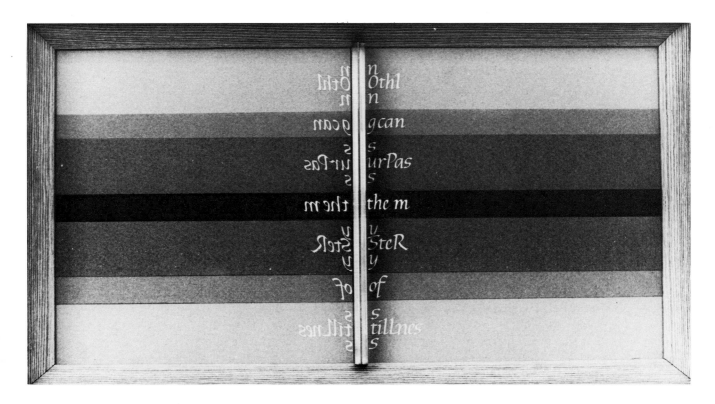

Peter Halliday
Poem 43 from a collection of 73 Poems by
E E Cummings. Brush-painted in
watercolour on black, light and dark blue
and grey paper with a double-sided
reflecting strip down the centre. Original
size (within frame) 15.2 × 30.4 cm
(6 × 12 in).
*Reproduced by permission of the agent for the
late E E Cummings.*

Jean Evans
Lettering. Approximate size of original
40.6 × 51 cm (16 × 20 in).

Impressed with the power and value of the written word,
SEQUOYA
felt if he could MAKE
THINGS
FAST
ON PAPER
it would be like
CATCHING
A WILD ANIMAL and
taming
it.
With the aid of an old English spelling book,
which he could not read, he began the task of committing his language to writing. At first
he tried to devise a sign for each word. After three years he abandoned this seemingly endless project,
and attempted instead to assign a symbol to each sound in the language. He found that 86 "letters" would
represent every sound in the CHEROKEE language. Despite ridicule and persecution
(once his house was burned down), he labored through 12 years of trial and error until in 1825. His syllabary was complete.
Then followed a long struggle to persuade his people to use the writing. Once the initial
opposition was overcome, the syllabary was used and remains in use
for all Cherokee literature. The Cherokees are the only American Indians
with a syllabary devised by one of their own people.
Its inventor was a Tennessee Cherokee named SEQUOYA.
He was a lame, uneducated half-caste, yet it was in honor
of him and his deeds that the great redwoods
came to be known as Sequoya.

54

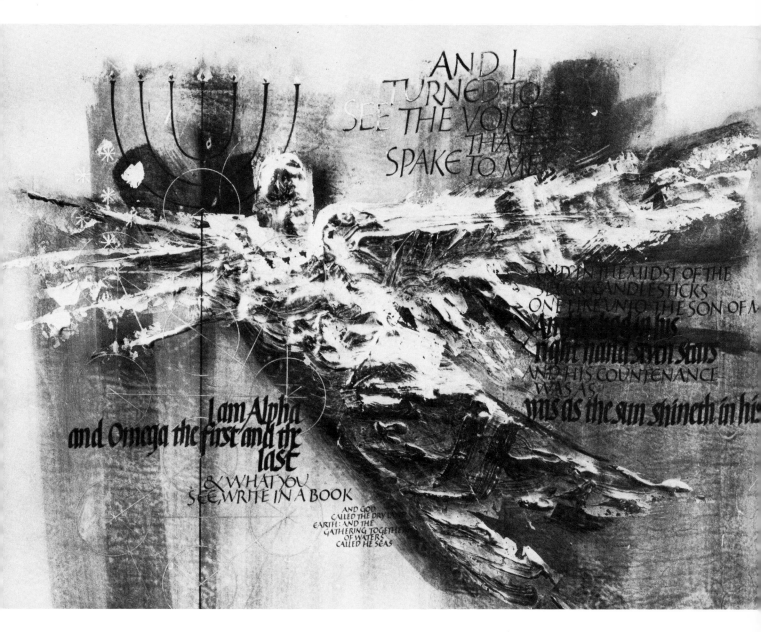

Within the artwork (calligraphic text):

AND I TURNED TO SEE THE VOICE THAT SPAKE TO ME

AND IN THE MIDST OF THE SEVEN CANDLESTICKS ONE LIKE UNTO THE SON OF M... AND... IN HIS right hand seven stars AND HIS COUNTENANCE WAS AS ...was as the sun shineth in his...

I am Alpha and Omega the first and the last
& WHAT YOU SEE WRITE IN A BOOK

AND GOD CALLED THE DRY L... EARTH: AND THE GATHERING TOGETHER OF WATERS CALLED HE SEAS

Donald Jackson
Detail from 'I am the Alpha and Omega'.
Written out in stick ink, gesso, gum
ammoniac, shell gilding and gouache on
vellum with quill and sponge. Height of
original 33 cm (13 in).

Overleaf
Alison Urwick
Centre pages of a manuscript book
presented to Heather Child in 1977 by
The Society of Scribes & Illuminators.
Written out in green, fawn and powdered
gold capitals on india paper. Hand bound
in vellum with silk ties, polished stones
and silver thread. Actual size.

"THE HARP
OF THE WOOD
PLAYS
MELODY,
ITS MUSIC"

...WITH THE WIND-BOWED ELDER BOUGHS AND THE PLIANT

LEAN ALL TO THE SWAYING BRIARY-TANGLE

THROUGH THE LONG AGES IT SINGS TO THE HOST A MELODY THAT IS NOT SAD...

BRINGS
PERFECT
PEACE; COLOUR HAS SETTLED
ON EVERY·HILL,
HAZE ON THE LAKE
OF FULL WATER.

ING OF THE WILD ELM (THAT SERVES WELL THE BOWYERS)
& THE RESISTANT LIMBS
OF THE TOUGH, KNARLED DERWEN EVEN
OAK TREE
LTERS LOW IN THE DEEPS OF THE VALLEY·WOOD
THE FRAGILE BLODYN-Y- GWYNT
FLOWER OF THE WIND
THE ENCLOSURES BRIGHT·WITH THE
OD-SORREL OF THE HOLLOWS, BY THE PLEASANT MARSHES
WHERE THE HINDS OFTEN COME.

TOWARDS ONE REALITY

THE
THRESHOLD
AWARD
FOR AN ESSENTIAL
CONTRIBUTION
WHICH HELPS LEAD
HUMANITY TOWARDS A
VISION OF REALITY
THAT INTEGRATES
ALL INTO A
SINGLE SACRED
WHOLE

IS PRESENTED TO
LEWIS
THOMAS

THE NINETEENTH DAY OF MAY
NINETEEN HUNDRED AND SEVENTY NINE

PRINCE CHAHRAM PAHLAVI-NIA
Threshold Foundation
PRESIDENT

DR· RAVI RAVINDRA
Threshold Award
DIRECTOR

ΟΥΤΟϹ ΗΝ ΕΝ
ΑΡΧΗ ΠΡΟϹ ΤΟΝ
ΘΕΟΝ ΠΑΝΤΑ ΔΙ'
ΑΥΤΟΥ ΕΓΕΝΕΤΟ
ΚΑΙ ΧΩΡΙϹ ΑΥΤΟΥ
ΟΔΕ ΕΝ Ο ΓΕΤΟ
ΝΕΝ.
ΕΝ ΑΥΤΩ ΖΩΗ ΗΝ
ΚΑΙ Η ΖΩΗ ΗΝ
ΤΟ ΦΩϹ ΤΩΝ
ΑΝΘΡΩΠΩΝ, ΚΑΙ
ΤΟ ΦΩϹ ΕΝ ΤΗ
ϹΚΟΤΙΑ ΦΑΙΝΑΙ
ΚΑΙ Η ϹΚΟΤΙΑ
ΑΥΤΟ ΟΥ ΚΑΤΕΛ
ΑΒΕΝ.
ΕΓΕΝΕΤΟ ΑΝΘΡ
ΩΠΟϹ ΑΠΕϹΤΑ
ΛΜΕΝΟϹ ΠΑΡΑ Θ
ΕΟΥ ΟΝΟΜΑ ΑΥΤ
Ω ΙΩΑΝΝΗϹ
ΟΥΤΟϹ ΗΛΘΕΝ
ΕΙϹ ΜΑΡΤΥΡΙΑΝ
ΙΝΑ ΜΑΡΤΥΡΗϹΗ
ΠΕΡΙ ΤΟΥ ΦΩΤ
ΟϹ ΙΝΑ ΠΑΝΤΕϹ

ΠΙϹΤΕΥϹΩϹΙΝ ΔΙ'
ΑΥΤΟΥ. ΟΥΚ ΗΝ
ΕΚΕΙΝΟϹ ΤΟ ΦΩ
Ϲ ΑΛΛ' ΙΝΑ ΜΑΡΤ
ΥΡΗϹΗ ΠΕΡΙ ΤΟΥ
ΦΩΤΟϹ.
ΗΝ ΤΟ ΦΩϹ ΤΟ
ΑΛΗΘΙΝΟΝ Ο ΦΩ
ΤΙΖΕΙ ΠΑΝΤΑ ΑΝ
ΘΡΩΠΟΝ ΕΡΧΟ
ΜΕΝΟΝ ΕΙϹ ΤΟΝ
ΚΟϹΜΟΝ.
ΕΝ ΤΩ ΚΟϹΜΩ Η
Η ΚΑΙ Ο ΚΟϹΜΟϹ
ΔΙ' ΑΥΤΟΥ ΕΓΕΝΕ
ΤΟ ΚΑΙ Ο ΚΟϹΜΟϹ
ΑΥΤΟΝ ΟΥΚ ΕΓΝω
ΕΙϹ ΤΑ ΙΔΙΑ ΗΛΘ
ΕΝ ΚΑΙ ΟΙ ΙΔΙΟΙ
ΑΥΤΟΝ ΟΥ ΠΑΡΕ
ΛΑΒΟΝ, ΟϹΟΙ ΔΕ
ΕΛΑΒΟΝ ΑΥΤΟΝ
Ϲ ΕΞΟΥϹΙΑΝ ΤΕΚ
ΝΑ ΘΕΟΥ ΓΕΝΕϹ
ΘΑΙ ΤΟΙϹ ΠΙϹΤΕ

ΥΟΥϹΙΝ ΕΙϹ ΤΟ Ο
ΝΟΜΑ ΑΥΤΟΥ ΟΙ
ΟΥΚ ΕΞ ΑΙΜΑΤων
ΟΥΔΕ ΕΚ ΘΕΛΗ
ΜΑΤΟϹ ϹΑΡΚΟϹ
ΟΔΕ ΕΚ ΘΕΛΗ
ΜΑΤΟϹ ΑΝΔΡΟϹ
ΑΛΛ' ΕΚ ΘΕΟΥ
ΕΓΕΝΝΗΘΗϹΑΝ
ΚΑΙ Ο ΛΟΓΟϹ ϹΑ
ΡΞ ΕΓΕΝΕΤΟ Κ
ΑΙ ΕϹΚΗΝΩϹΕΝ
ΕΝ ΗΜΙΝ
ΚΑΙ ΕΘΕΑϹΑΜΕΘΑ
ΤΗΝ ΔΟΞΑΝ ΑΥΤΟΥ
ΔΟΞΑΝ ΩϹ ΜΟΝΟ
ΓΕΝΟΥϹ ΠΑΡΑ ΠΑΤΡΟϹ
ΠΛΗΡΗϹ ΧΑΡΙΤΟϹ
ΚΑΙ ΑΛΗΘΕΙΑϹ
ΙΩΑΝΝΗϹ ΜΑΡΤΥΡ
ΕΙ ΠΕΡΙ ΑΥΤΟΥ ΚΑΙ
ΚΕΚΡΑΓΕΝ ΛΕΓΩΝ
ΟΥΤΟϹ ΗΝ ΟΝ
ΕΙΠΟΝ Ο ΟΠΙϹΩ
ΜΟΥ ΕΡΧΟΜΕΝοϹ
ΕΜΠΡΟϹΘΕΝ ΜΟΥ

ΓΕΓΟΝΕΝ, ΟΤΙ Π
ΡΩΤΟϹ ΜΟΥ ΗΝ,
ΟΤΙ ΕΚ ΤΟΥ ΠΛΗ
ΡΩΜΑΤΟϹ ΑΥΤΟΥ
ΗΜΕΙϹ ΠΑΝΤΕϹ
ΕΛΑΒΟΜΕΝ ΚΑΙ
ΧΑΡΙΝ ΑΝΤΙ ΧΑΡΙ
ΤΟϹ ΟΤΙ Ο ΝΟΜ
ΟϹ ΔΙΑ ΜΩΥϹΕως
ΕΔΟΘΗ Η ΧΑΡΙϹ
ΚΑΙ Η ΑΛΗΘΕΙΑ
ΔΙΑ ΙΗϹΟΥ ΧΡΙϹΤ
ΟΥ ΕΓΕΝΕΤΟ.
ΘΕΟΝ ΟΥΔΕΙϹ Ε
ΩΡΑΚΕΝ ΠΩΠΟ
ΤΕ ΜΟΝΟΓΕΝΗϹ
ΘΕΟϹ Ο ΩΝ ΕΙϹ
ΤΟΝ ΚΟΛΠΟΝ ΤΟΥ
ΠΑΤΡΟϹ ΕΚΕΙΝΟ
Ϲ ΕΞΗΓΗϹΑΤΟ.
ΚΑΙ ΑΥΤΗ ΕϹΤΙΝ
Η ΜΑΡΤΥΡΙΑ ΤΟΥ
ΙΩΑΝΝΟΥ ΟΤΕ Α
ΠΕϹΤΕΙΛΑΝ ΠΡ
ΟϹ ΑΥΤΟΝ ΟΙ ΙΟ
ΥΔΑΙΟΙ ΕΞ ΙΕΡΟϹ

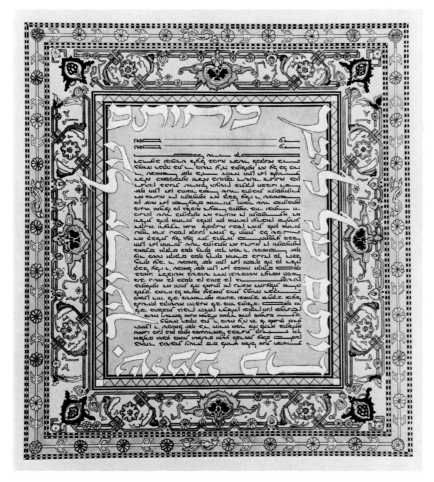

Stanley Knight
Text page of St John's Gospel written in
Greek uncials on vellum. The writing
in blue and black ink and raised gold.
Original size 17.7 × 25.4 cm (7 × 10 in).

Cara Goldberg Marks
Wedding contract. Written out in ink and
watercolour. Collection Tzipporan
Brandes, Hong Kong.

Facing page
Donald Jackson
'The Threshold Award'. A presentation
certificate written out in raised gold and
black ink on paper. Original size
50 × 28 cm (19¾ × 11 in).

Yo' airn't the man yo' mamma wuz

Colleen
Graffiti on a wall in Chicago 1971.
Original size 63.7 × 101.6 cm
(26 × 40 in).

Jovica Veljovic
Decorative lettering.
Written in ink with a wooden stick on
paper.
Original size 11.5 × 17 cm (4¾ × 6⅞ in).

60

Villu Toots
'Ann'. Experimental page of letters in brown, red and orange. Original size 38.5 × 28 cm (15 × 11 in).

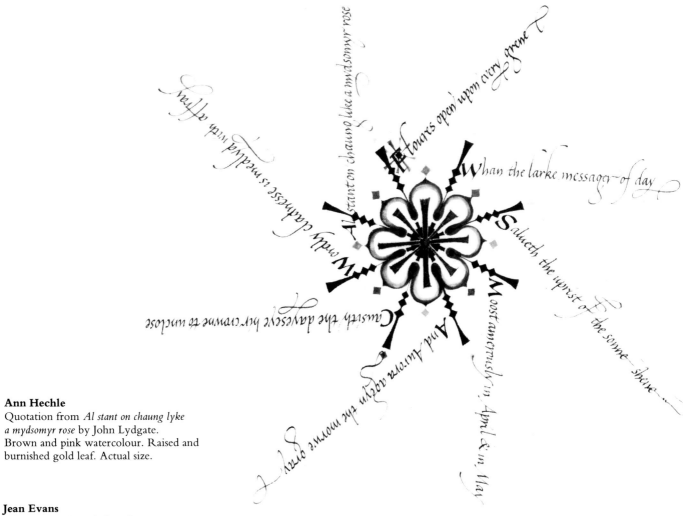

Ann Hechle
Quotation from *Al stant on chaung lyke
a mydsomyr rose* by John Lydgate.
Brown and pink watercolour. Raised and
burnished gold leaf. Actual size.

Jean Evans
'The Centipede'. Black and grey sumi
stick ink and gold watercolour on
watercolour paper. Approximate size of
original 75 × 250 cm (30 × 10 in).

BUTINTHE *Art* OF *Calligraphy*

ASINALLARTSTHEIDEAINTHEMI
NDISTHEULTIMATEYARDSTICK
BYWHICHWEEVALUATEMERITIN
THEART·PRODUCT·THETECHNIC
ALPRE-REQUISITES·TOOLS·MAT
ERIALS·ANDMETHODOFWORK
ING·THOUGHNEEDED·AREALW
AYSSUBORDINATETOTHEIRME
NTALEXEMPLAR·TECHNIQUEIS
ONLYAMEANS·SKILLFULLYWRO
UGHTEXPRESSIONSOFINCONSE
QUENTIALIDEASAREMORELIKE
LYTOAROUSEDISMAYTHANAD
MIRATION·POORLYWRITTENLE
TTERSSKILLFULLYCHISELLEDARE
ALWAYSUGLIERTHANWELL-WRI
TTENLETTERSPOORLYCUT·SINCE
ADEFECTINTHEMEANSISLESSDA
MAGINGTHANADEFECTINTHE
MENTALPATTERN/ FATHER CATICH

Jovica Veljovic
'But in the Art of Calligraphy . . .'
Original size 44 × 32.5 cm (17 × 12½ in).

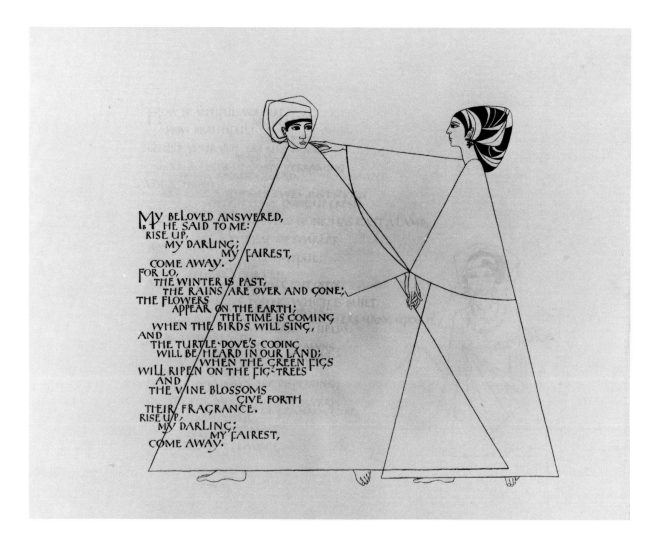

Alison Urwick
Extract from *The Song of Songs*. Written out in Chinese ink and watercolour with brush on hand-made paper. Original size 29.8 × 23.4 cm (11¾ × 9¼ in).

David Williams
Alphabet. Actual size.

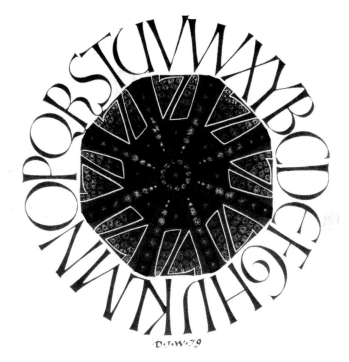

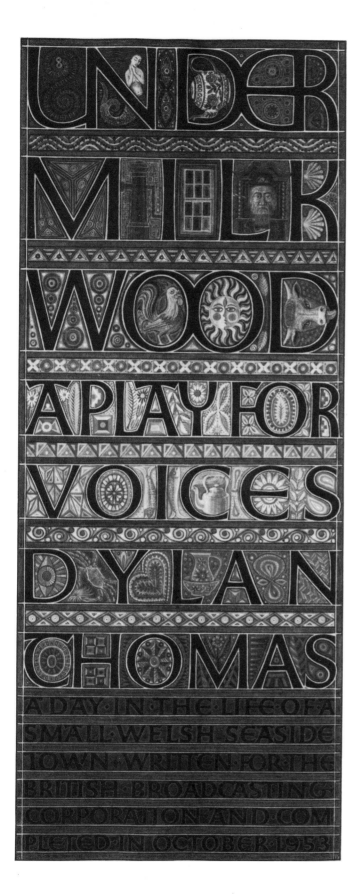

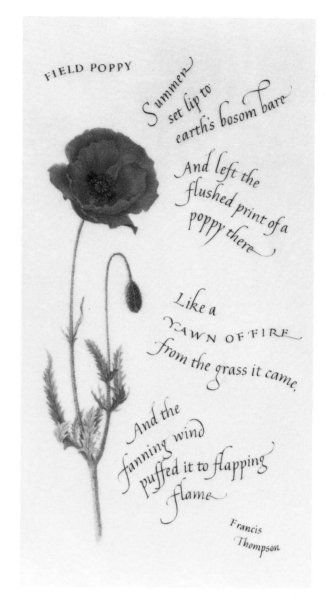

FIELD POPPY

Summer
set lip to
earth's bosom bare

And left the
flushed print of a
poppy there

Like a
YAWN OF FIRE
from the grass it came,

And the
fanning wind
puffed it to flapping
flame

Francis
Thompson

Sheila Waters

Left: Title page lettering of *Under Milk Wood* by Dylan Thomas. Manuscript book commissioned by Edward Hornby Esq. Original size of lettering panel illustrated here 27.3 × 11.4 cm (10$\frac{3}{4}$ × 4$\frac{1}{2}$ in). Overall page size 37.8 × 25.4 cm (14$\frac{1}{2}$ × 10 in).

Above: Field Poppy. Original size 17 × 9.3 cm (6$\frac{5}{8}$ × 3$\frac{5}{8}$ in).

Overleaf: Two pages from a manuscript book of *Under Milk Wood* by Dylan Thomas. Commissioned by Edward Hornby Esq. Original page size 37.8 × 25.4 cm (14$\frac{1}{2}$ × 10 in).

the roof of Handel Villa see the Women's
Welfare hoofing, bloomered, in the moon.

At the sea-end of town, Mr and Mrs Floyd,
the cocklers, are sleeping as quiet as death,
side by wrinkled side, toothless, salt and
brown, like two old kippers in a box.
And high above, in Salt Lake Farm, Mr Utah
Watkins counts, all night, the wife-faced
sheep as they leap the fences on the hill,
smiling and knitting and bleating just like
Mrs Utah Watkins.

Yawning Thirty-four, thirty-five, thirty-six, forty-eight, UTAH WATKINS
eighty-nine...

Bleating Knit one slip one MRS UTAH WATKINS
Knit two together
Pass the slipstitch over...

Ocky Milkman, drowned asleep in Cockle FIRST VOICE
Street, is emptying his churns into the Dewi
River,

Whispering regardless of expense, OCKY MILKMAN
and weeping like a funeral. FIRST VOICE
Cherry Owen, next door, lifts a tankard to SECOND VOICE
his lips but nothing flows out of it. He shakes
the tankard. It turns into a fish. He drinks
the fish.
P.C.Attila Rees lumps out of bed, dead to FIRST VOICE
the dark and still foghorning, and drags out
his helmet from under the bed; but deep

13

Softly WHAT seas did you see, ROSIE PROBERT
Tom Cat, Tom Cat,
In your sailoring days
Long long ago?
What sea beasts were
In the wavery green
When you were my master?

I'll tell you the truth. CAPTAIN CAT
Seas barking like seals,
Blue seas and green,
Seas covered with eels
And mermen and whales.

What seas did you sail ROSIE PROBERT
Old whaler when
On the blubbery waves
Between Frisco and Wales
You were my bosun?

As true as I'm here CAPTAIN CAT
Dear you Tom Cat's tart
You landlubber Rosie
You cosy love
My easy as easy
My true sweetheart,
Seas green as a bean
Seas gliding with swans
In the seal-barking moon.

59

Peter Halliday
Vision and Prayer by Dylan Thomas from
The Poems published by J M Dent & Sons
Ltd and New Directions Inc. (Reproduced
by permission of the Trustees of the late
Dylan Thomas.) Original size
55.8 × 22.8 cm (21¾ × 8⅞ in).

Facing page
Charles Pearce
Declaration of Independence. Manuscript
book in a private collection. Written out
and decorated in gold and silver leaf and
gouache with pens and brushes on hand-
made paper. Original size 43 × 58.4 cm
(17 × 23 in).

Facing page
Donald Jackson
Letter patent granting the Borrowing of
the Charter of Armsfield. Written out in
Chinese stick ink, gesso ammoniac and
powdered gilding with quills and brush.
Original size 41.9 × 55.8 cm
(16½ × 22 in).
Courtesy, Lord Chartris of Armsfield.

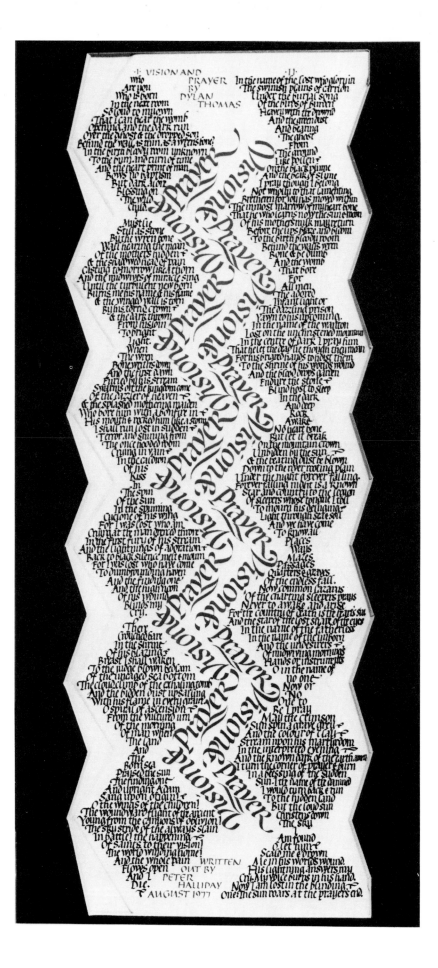

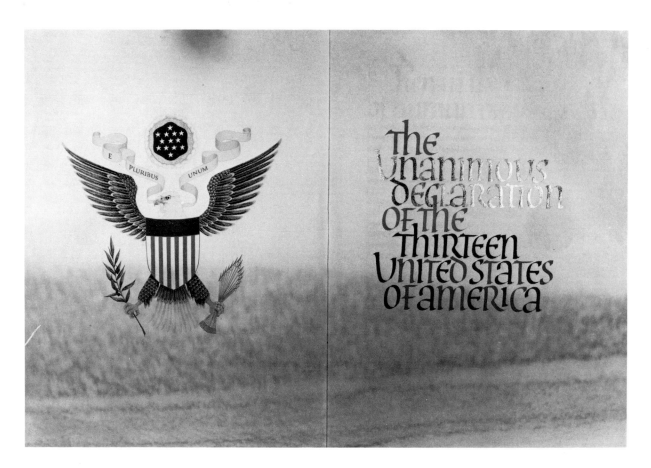

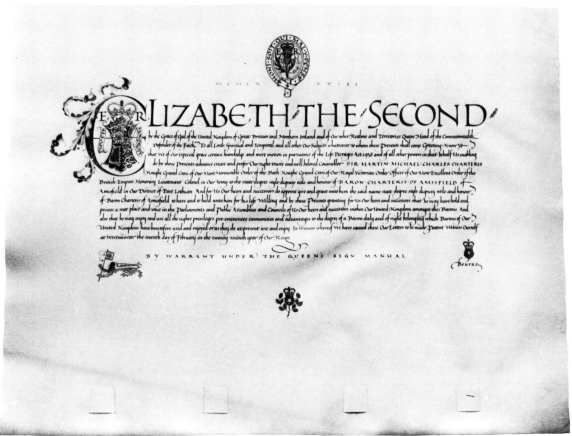

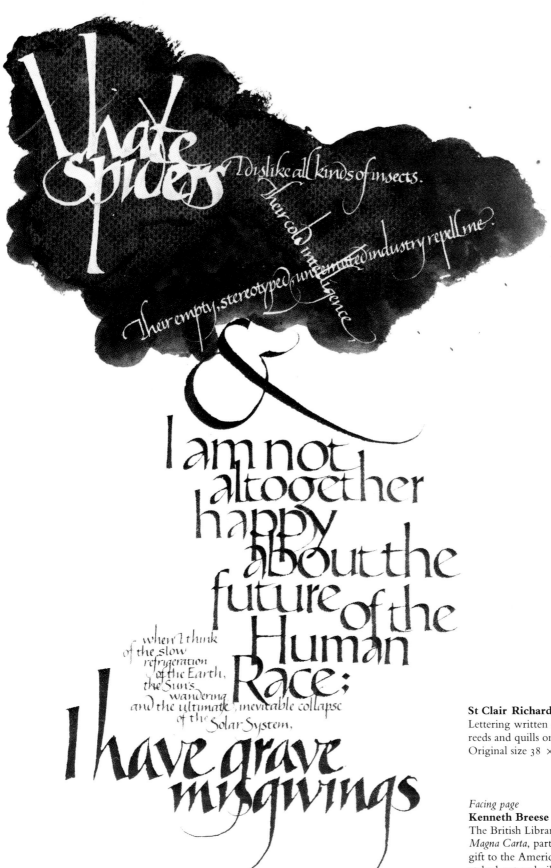

I hate spiders. I dislike all kinds of insects. Their cold unremitted industry repel me. Their empty, stereotyped, unintelligence & I am not altogether happy about the future of the Human Race: when I think of the slow refrigeration of the Earth, the Sun's wandering and the ultimate, inevitable collapse of the Solar System, I have grave misgivings

St Clair Richard
Lettering written out in Sumi ink with reeds and quills on hand-made paper. Original size 38 × 30.4 cm (15 × 12 in).

Facing page
Kenneth Breese
The British Library Translation of the *Magna Carta*, part of the Bicentennial gift to the American People. Final version etched out and gilded on clear glass. Original size 41.8 × 24.2 cm (19 × 11 in).

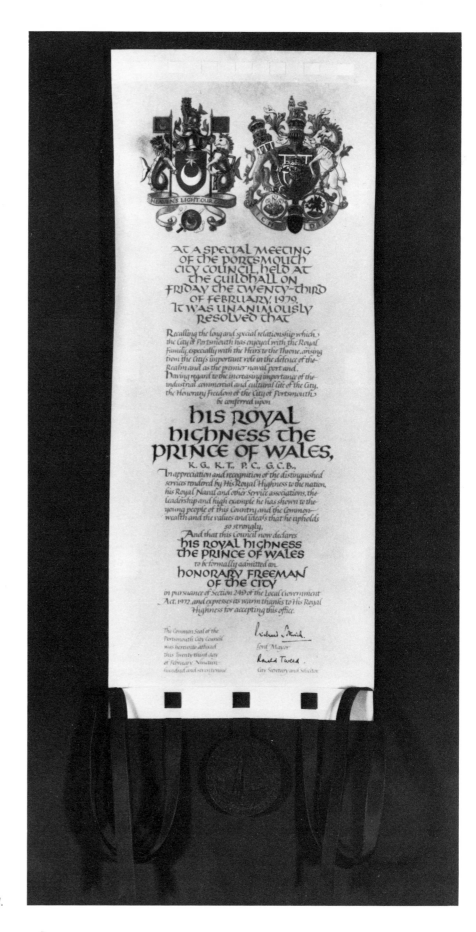

David Graham
Freedom Scroll presented by the City of
Portsmouth to HRH the Prince of Wales.
Main text in blue. Decorated with raised
and flat gold. Surface: Vellum. Original
size 58 × 23.5 cm (22½ × 9 in).
*By gracious permission of HRH the Prince of
Wales and courtesy of Portsmouth City Council.*

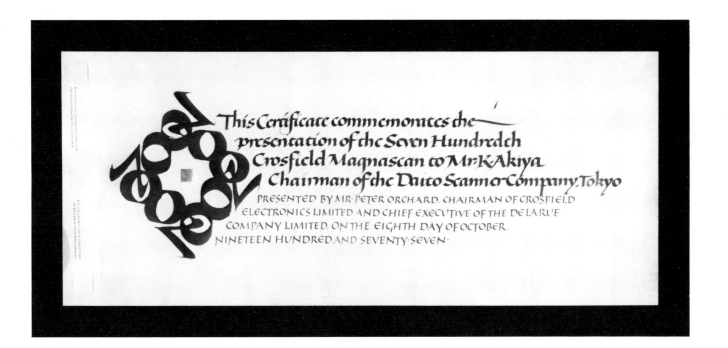

Donald Jackson
Presentation certificate written out in black stick ink and powder gold with quill pen on vellum. Original size 19 × 40.6 cm (7½ × 16 in).

Ina Saltz
Quotation from the book of *Deuteronomy*. Written out in gouache with Mitchell nibs on Canson paper. Original size 38.7 × 32.3 cm (15¼ × 12¾ in).

New York City Ballet

John E Benson
Brush lettering. Brush and ink on Japanese paper. Width of original 23.7 cm (9¼ in).

Linda Christensen
Lettering written out in frisket, watercolour wash and gouache on watercolour paper with Speedball nibs.

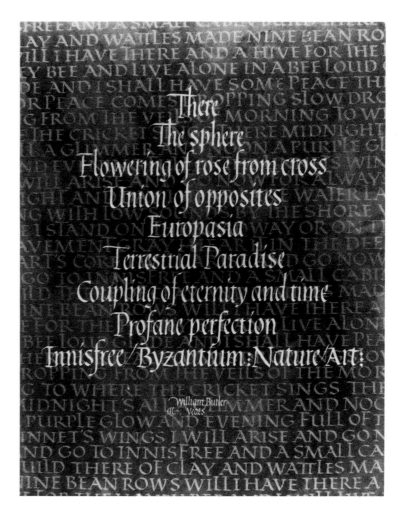

As if
you could
kill time
without

injuring eternity.
Thoreau

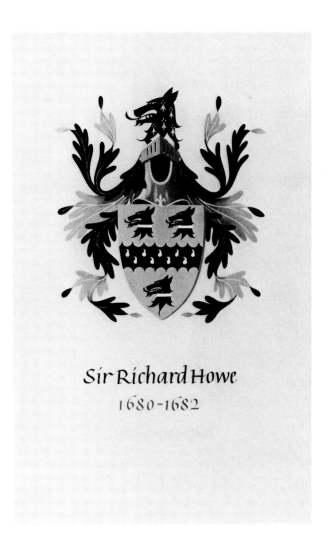

Sir Richard Howe
1680-1682

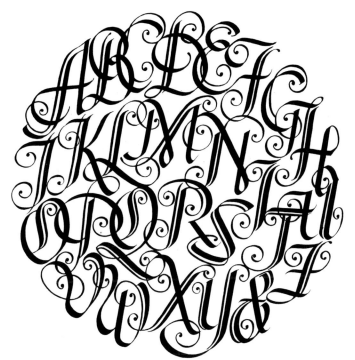

Paul Shaw
Quotation from Thoreau. Original size
28 × 21.5 cm (11 × 8⅜ in).

Joan Pilsbury
Record of Arms of the Prime Wardens of
The Fishmonger's Company, Volume I.
Full colour and gold on vellum. Original
size 31.7 × 24 cm (12½ × 9½ in).

Vera Ibbett
Alphabet design. Diameter of original
16.8 cm (6 in).

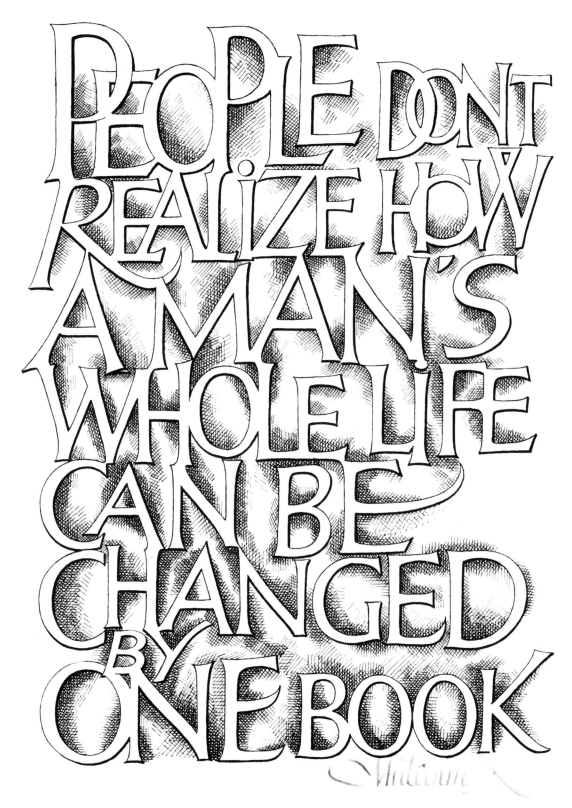

William Metzig
Quotation from Malcolm X. Written out
in inks on paper. Original size 36.8 ×
26 cm (14½ × 10¼ in).

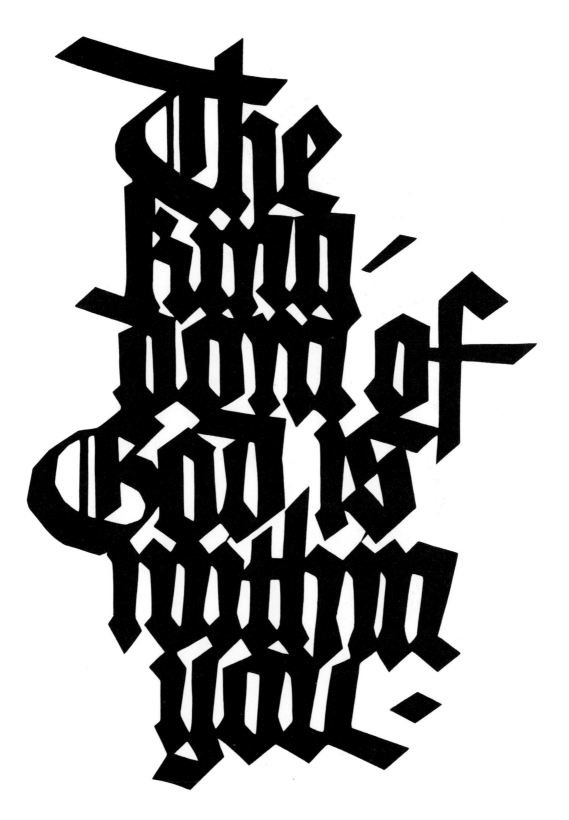

Guillermo Rodriguez-Benitez
Letters cut from a heavy black paper and
mounted on white paper. Original size
28 × 19 cm (11 × 7½ in).

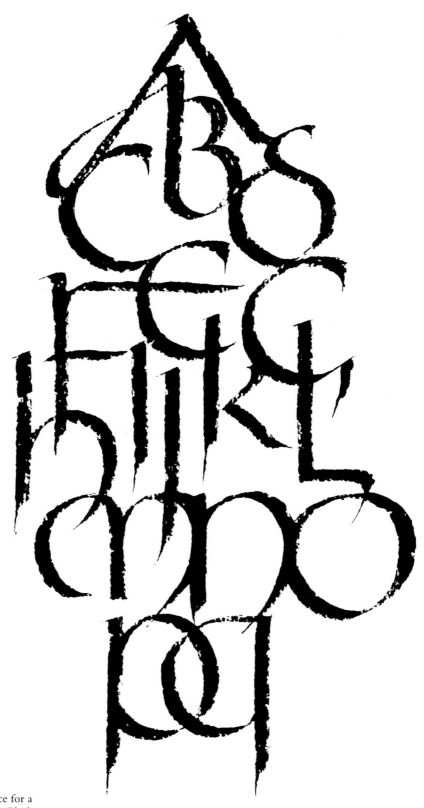

Maura Cooper Barnard
'Uncial design'. Exhibition piece for a
show at the Brooklyn Museum. Black
India ink on De Wint paper.
Original size 33 × 20 cm (13 × 8 in).

Werner Schneider
Lettering. Original size 58.5 × 37.5 cm
(23 × 15 in).

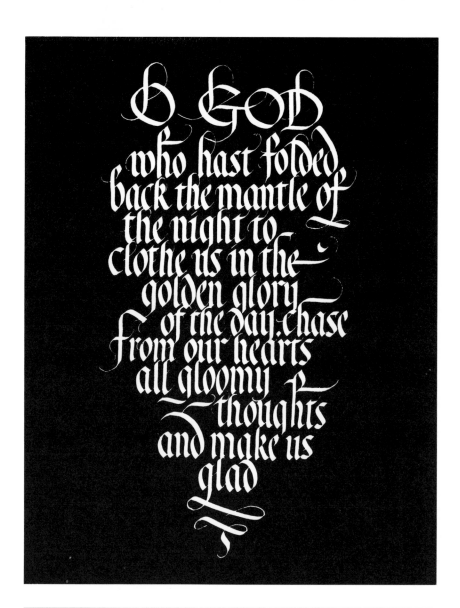

Dorothy Avery
Lettering in white gouache on black paper. Approximate size of original 54 × 28.6 cm (7 × 13 in).

Margery Raisbeck
Lettering. Original size 13.9 × 20.2 cm (5½ × 8 in).

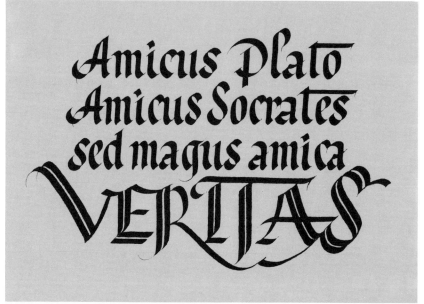

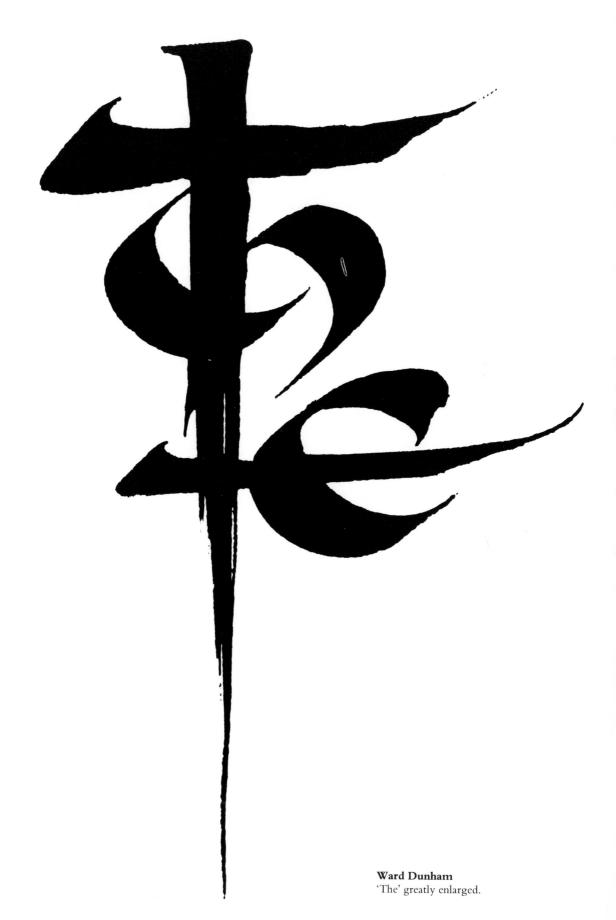

Ward Dunham
'The' greatly enlarged.

AND WHAT IS LIFE? –

JOHN CLARE

A mist retreating from the morning sun,

AN HOUR-GLASS

A busy, bustling, still repeated dream.

ON THE RUN,

Wendy Westover
Quotation from John Clare. Alternate
lines in brown and white. Brush and fine
pen lettering on Kraft paper. Original size
35.5 × 55.8 cm (14 × 22 in).

John Weber
Quotation from Mahatma Gandhi.
Commissioned by Joyce Miller of CARE,
an organization helping needy people
around the world. Original size
22.8 × 30.4 cm (9 × 12 in).

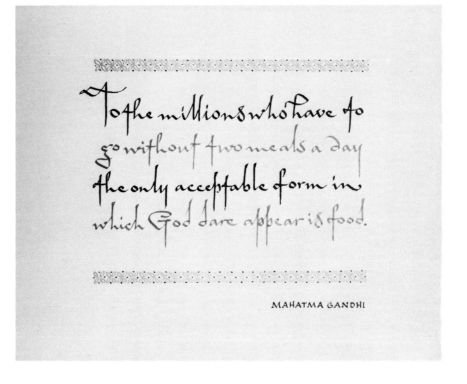

To the millions who have to
go without two meals a day
the only acceptable form in
which God dare appear is food.

MAHATMA GANDHI

In order that the foresaid injurious efforts of the king of England may the more conveniently be repressed and that the said king be the more quickly compelled to withdraw from his perverse and hostile incursions, the said king of Scots shall take care to begin and continue war against the king of England at his own cost and expense with all his power and with all the power of his subjects and of his kingdom, as often as it be opportune. The prelates of Scotland, as far as it be lawful to them, with the earls barons and other nobles and also the universitates ac communitates villarum of the kingdom of Scotland shall make war against the said king of England in the same manner as is above expressed, with all their strength. The prelates earls barons and other nobles and also the universitates communitatesque notabiles of the said kingdom of Scotland shall direct to us as soon as may be their letters patent hereon fortified with their seals

It was also agreed that if it happen the foresaid king of England to invade the kingdom of

S

cotland by himself or by another after war has begun by the king of Scots at our request or after this present agreement or treaty has been entered upon between us by occasion thereof we provided we be forewarned thereof on the part of the same king of Scots within a suitable time, shall give him help by occupying the said king of England in other parts, so that he shall thus be distracted to other matters from the foresaid invasion which he has begun. If however, the foresaid king of England happens personally to leave England or goes out of it with a notable number of infantry or cavalry while war lasts between him and us, then especially the said king of Scotland with all his power shall take care to invade the land of England as widely or deeply as he can

George Thomson
'Treaty with France 1295'. Written out in
ink and watercolour with raised gilding
on hand-made paper. Original size
50 × 37 cm (19½ × 14⅜ in).

Alice
Poster. The original is an unretouched
piece for exhibition, later reproduced in
the same size as a poster for a lecture series.
Original size 59.6 × 47 cm ($23\frac{1}{2}$ × $18\frac{1}{2}$ in).

> For a long time it had seemed to me
> that life was about to begin—real life.
> But there was always some obstacle in the way.
> Something to be got through first,
> some unfinished business; time still to be served,
> a debt to be paid. Then life would begin.
> At last it dawned on me
> that these obstacles were my life.
>
> B. HOWLAND · Calligraphy by David Mekelburg

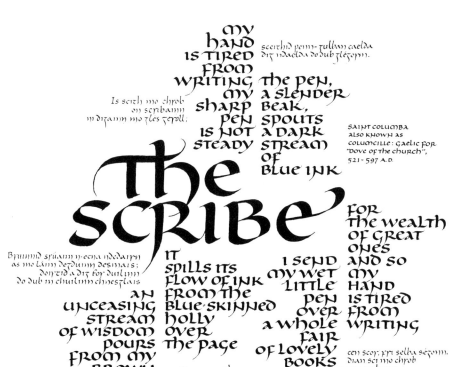

David Mekelburg
A quotation from the book *Life in the Snakepit* by Bette Howland. Written out in Chinese stick ink with an automatic pen on Strathmore Kid Finish Bristol.

Terry O'Donnell
'The Scribe'. Written out in ink and gouache with a metal and nylon pen on Saunders hand-made paper. Original size 33 × 45 cm (13 × 17 in).

Theo Varlet

AN EDUCATION THROUGH BOOKS

is a companion which no misfortune
can depress – no crime destroy –
no enemy alienate, – no despotism
enslave.

* At home, a friend; abroad an
introduction; in solitude, a solace;
and in society an ornament.

Without books, what is man?

Hermann Zapf
Quotation by Theo Varlet.
Commissioned for The San Francisco
Public Library for their collection of
calligraphy.

Calligraphy and lettering for reproduction

Ivan THE TERRIBLE & Ivan THE FOOL

David Gatti
Lettering for a bookjacket. Width of original artwork 29.6 cm ($11\frac{5}{8}$ in).

Pat Topping
Christmas greetings card. Printed size 14×14 cm ($5\frac{1}{2} \times 5\frac{1}{2}$ in).

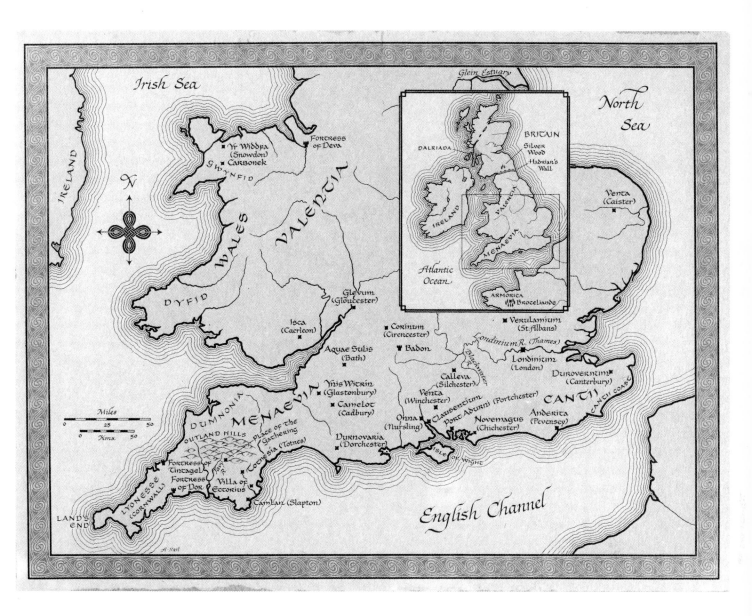

Within the map:

Irish Sea

North Sea

Ireland

Yr Widdfa
(Snowdon)
Carbonek
Gwynfid
Fortress
of Deva

Glein Estuary

BRITAIN
DALRIADA
Silver
Wood
Hadrian's
Wall
IRELAND
VALENCIA
MENAEVIA
ARMORICA
Broceliande
Atlantic
Ocean

Venta
(Caister)

WALES
VALENCIA

DYFID

Glevum
(Gloucester)

Isca
(Caerleon)

Aquae Sulis
(Bath)

Corinium
(Cirencester)
Badon

Vertulamium
(St. Albans)

Londinium R. (Thames)

Blackwater

Londinium
(London)

Duroverntum
(Canterbury)

Ynis Witrin
(Glastonbury)

Camelot
(Cadbury)

Calleva
(Silchester)

Venta
(Winchester)

Clausentium

CANTII

CANTII COAST

N

DUMNONIA

MENAEVIA

Durnovaria
(Dorchester)

Onna
(Nursling)

Port Adurni (Portchester)

Novemagus
(Chichester)

Anderita
(Pevensey)

OUTLAND HILLS

PLACE OF THE
GATHERING

Cocnesia (Totnes)

Isle of Wight

Miles
0 25 50
Kms.
0 50

Fortress of
Tintagel
Fortress
of Vor

Villa of
Ectorius

Camlan (Slapton)

LYONESSE
(CORNWALL)

LAND'S
END

English Channel

A. Karl

Anita Karl
Endpapers for *The Pendragon* by Catherine
Christian, published by Alfred Knopf.
1979.

David Mekelburg
Calligraphic letterheading.

Donald K. Adams

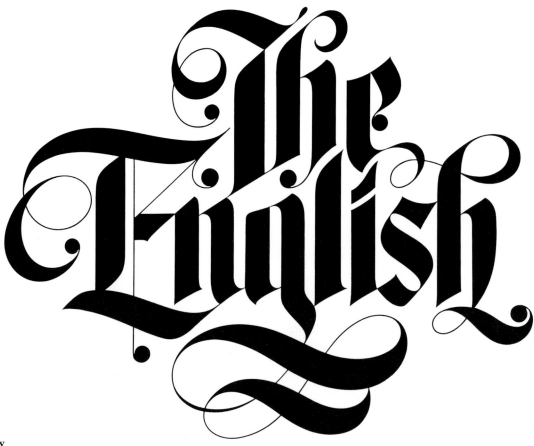

David Quay
Lettering for a bookjacket. Width of
original artwork 25.4 cm (10 in).

David Kindersley
Two bookplates. Actual printed size.

The Canterbury Tales

The Canterbury Tales
Chaucer

Geoffrey Chaucer

An illustrated selection rendered into modern English by Nevill Coghill

Nancy Winters
Calligraphy for *The Canterbury Tales* published in 1977 by Penguin. Shown here on the jacket but used throughout the book for titles and headings. Printed size 21 × 19 cm (8¼ × 7½ in).

Bo Berndal
Christmas greetings card. Original width
of lettering 12.6 cm (4⅞ in).

Gerry Fleuss and Lida Lopes Cardozo
Bookplate. Actual printed size.

Kenneth Breese
Handpainted symbol for the Gordon
Restaurant, Scotland.

Irene Alexander
Bookplate designed for personal use and to raise money for the Society for Italic Handwriting British Columbia. Written out with William Mitchell round-hand nibs number oo, 3, 4 and 5. The name area, 'This book belongs to' and the surrounding lettering in red. All other lettering in black. Actual printed size. Original size 15.2 × 20.3 cm (6 × 8 in).

Umbertina

Muriel Nasser
Lettering for a bookjacket.

Donald Jackson
Press advertisement. Written out in stick ink with quill on layout paper. Original size 20.3 × 10 cm (8 × 4 in). Actual printed size. *Courtesy of the Craftwork Gallery.*

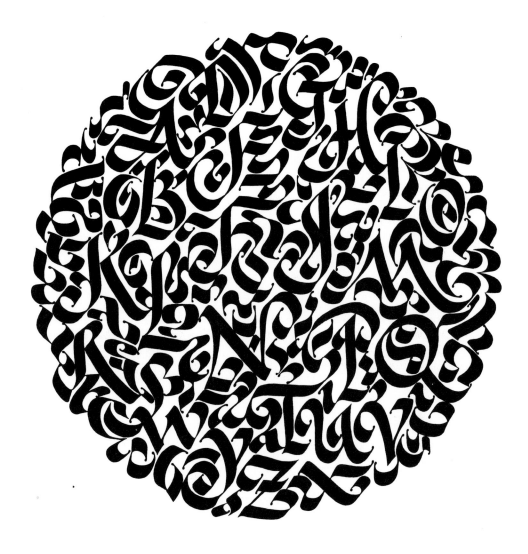

John Weber
Alphabet rosette used as a logotype on John Weber's personal stationary. Diameter of original 51 cm (20 in).

Bo Berndal
Two bookplates. Actual printed size. Original width of lettering 'JB' 5.2 cm (2 in). Original width of oval 'Peo Kjellgren' 9 cm (3½ in).

DAS AUSAE LAUTEN

In meiner Heimat lebt der Brauch:
ist verronnen der Wahe-Rauch,
liegt der Tote im Grabe,
klumpt auf den Sarg die Schollengabe,
so tönen auf einmal alle Glocken.
Und blieb ein Seelefünklein wo hocken,
ein Atem bloß, ein Seufzer, der bang
vorm Tode in die Büsche entsprang:

die Glocken ernten alles ein,
ihr Echo betet in Dickicht und Hain,
sie beschreien den Acker, besingen den Hang
mit erzenem Munde, mit der Ewigkeit Klang!

Sie schwellen ums Haus, verjagen den Alb,
sie schlucken noch der Dinge Hauch,
sie drängen den Toten von Roß und Kalb,
zerren zuletzt ihn vom Hunde auch.

Richard Billinger

Herbstbeginn

Der Hirte singt zum Abendstern.
Im Apfel bräunet sich der Kern.
Wipfelmüd die Bäume schwägen.
Nebel in die Wiesen steigen.
Beere sich an Beere hängt.
Zur Aster sich die Hummel drängt.
Der Kern aus reifer Pflaume quoll.
Ein Birnlein in der Faust mir schwoll.
Ich sauge mich ins Fruchtfleisch ein,
die Wange heiß vom ersten Wein.

Richard Billinger

Friedrich Neugebauer
Two pieces from *Der Garten Haucht* by
Richard Billinger. Printed size
28.5 × 12.8 cm (11¼ × 5 in).

FOR
UNTO US
A CHILD
IS BORN,
UNTO US
A SON
IS GIVEN:
AND HE
SHALL BE
CALLED
THE PRINCE
OF PEACE

John Prestianni
Christmas greetings card. Actual printed
size.

John Smith
Book mark. Actual printed size.

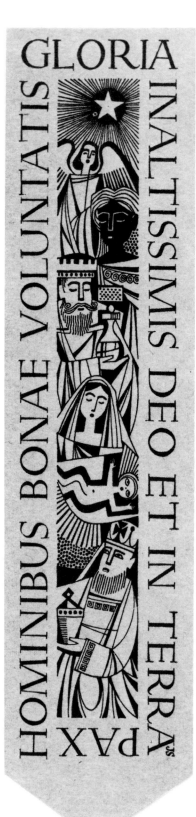

GLORIA IN ALTISSIMIS DEO ET IN TERRA
PAX HOMINIBUS BONAE VOLUNTATIS

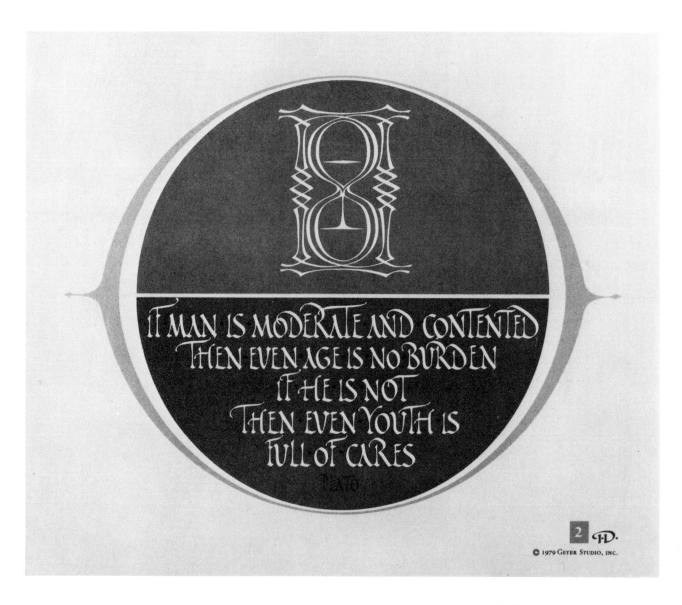

IF MAN IS MODERATE AND CONTENTED
THEN EVEN AGE IS NO BURDEN
IF HE IS NOT
THEN EVEN YOUTH IS
FULL OF CARES
PLATO

2 HD.
© 1979 GEYER STUDIO, INC.

Ismar David
One of a set of seventeen style examples
from the Geyer Studio writing book, *Our
Calligraphic Heritage*. Printed size
18×21.6 cm ($7 \times 8\frac{7}{8}$ in).

Ieuan Rees
Letterheading. Actual printed size.

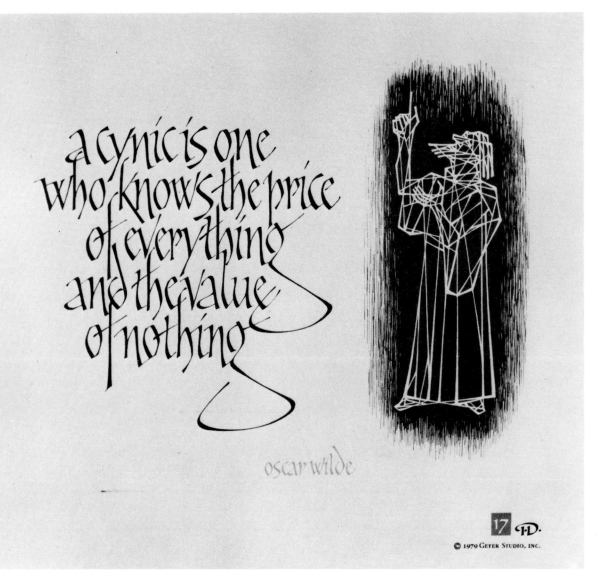

© 1979 Geyer Studio, Inc.

Ismar David
One of a set of seventeen style examples
from the Geyer Studio writing book, *Our
Calligraphic Heritage*. Printed size
18 × 21.6 cm (7 × $8\frac{7}{8}$ in).

Marie Angel
Left: Decorative initial from *Bird, Beast
and Flower*. A book of poems to be
published in 1980 by Chatto and Windus
Limited, London.

Right: Decorative initial from *Tucky the
Hunter* by James Dickey. Illustrated by
Marie Angel, published in 1978 by Crown
Publishers Inc., New York.

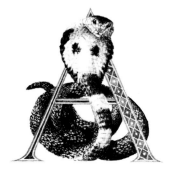

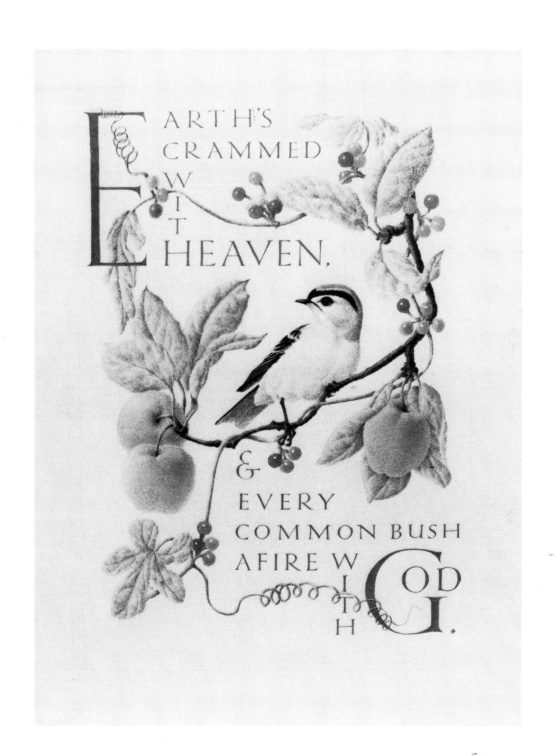

EARTH'S CRAMMED WITH HEAVEN, & EVERY COMMON BUSH AFIRE WITH GOD.

Marie Angel
Quotation from *Aurora Leigh* by Elizabeth Barrett Browning. One of twelve drawings for a calendar, published in 1979 by the Green Tiger Press, La Jolla, California.

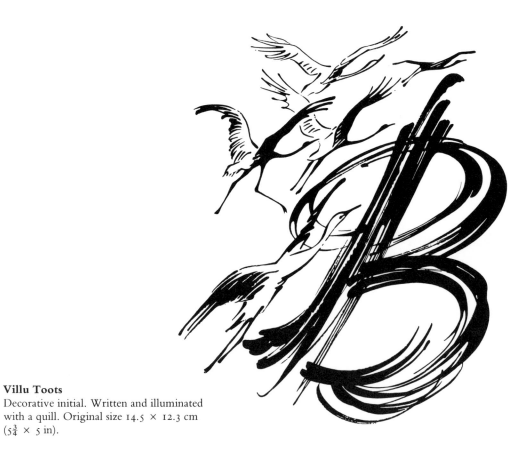

Villu Toots
Decorative initial. Written and illuminated
with a quill. Original size 14.5 × 12.3 cm
($5\frac{3}{4}$ × 5 in).

Villu Toots
Two bookplates. Actual printed size.

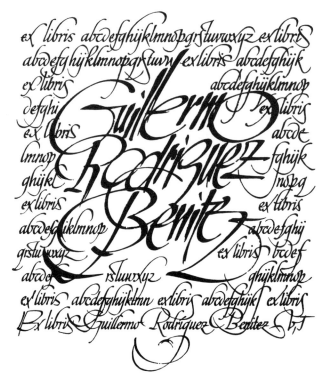

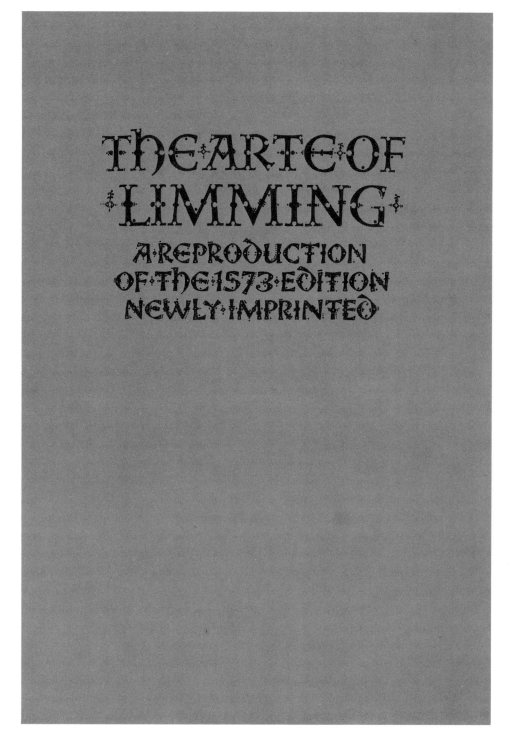

THE·ARTE·OF
·LIMMING·
A·REPRODUCTION
OF·THE·1573·EDITION
NEWLY·IMPRINTED

Michael Gullick
Front cover to *The Art of Limming*
published by the Society of Scribes and
Illuminators, London, 1979. Actual
printed size.

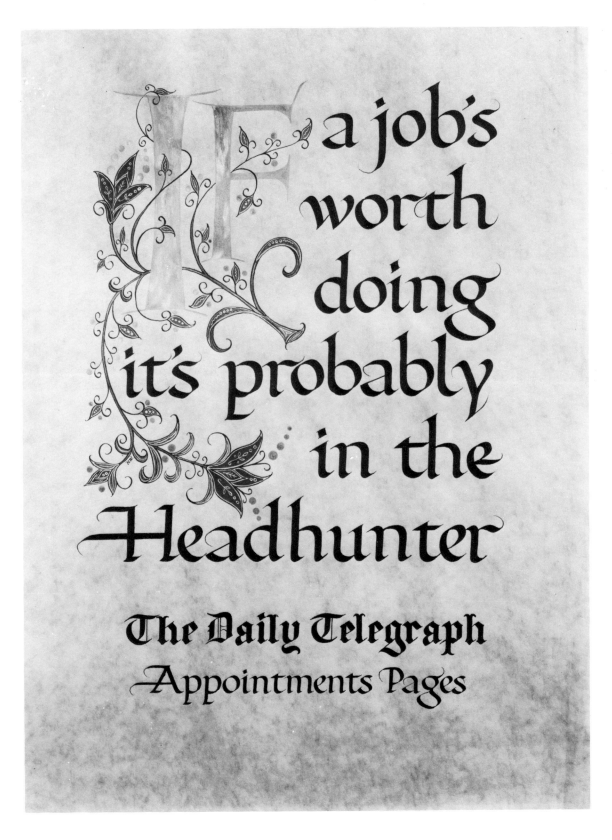

Nancy Winters
Poster for *The Daily Telegraph*.
Reproduced for display on station
hoardings. Printed size 152 × 102 cm
(59¼ × 39¾ in).

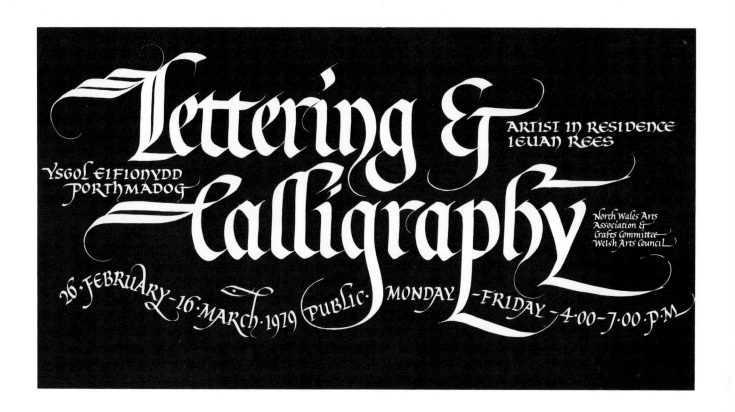

Ieuan Rees
Poster design. White on olive green.
Printed size 21.5 × 40.6 cm (8½ × 16 in).

James Hayes
Calligraphy for the Pentalic-Taplinger
Calendar 1980. Printed size
21.5 × 21.5 cm (8½ × 8½ in).

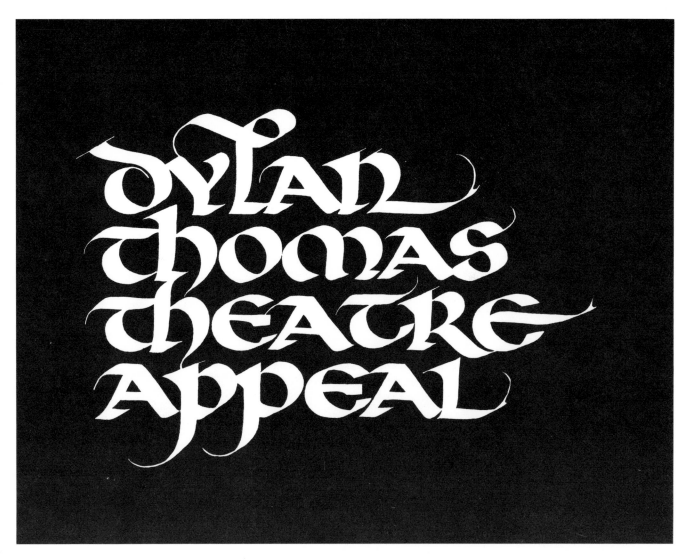

Ieuan Rees
Design for brochure and poster. Later to be incorporated in the facia of the Dylan Thomas Theatre. White letters reversed out of dark brown. Brochure size 14.7 × 19 cm (5⅞ × 7½ in).

Peter Halliday
Christmas greetings card. Original size 16.5 × 21 cm (6½ × 8¼ in). Printed size 8.2 × 10.4 cm (3¼ × 4½ in).

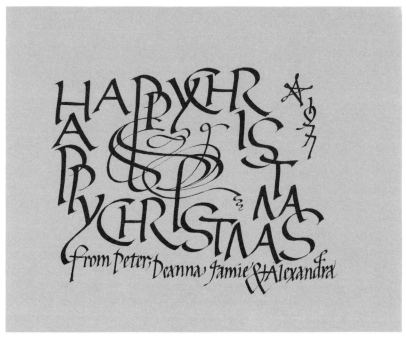

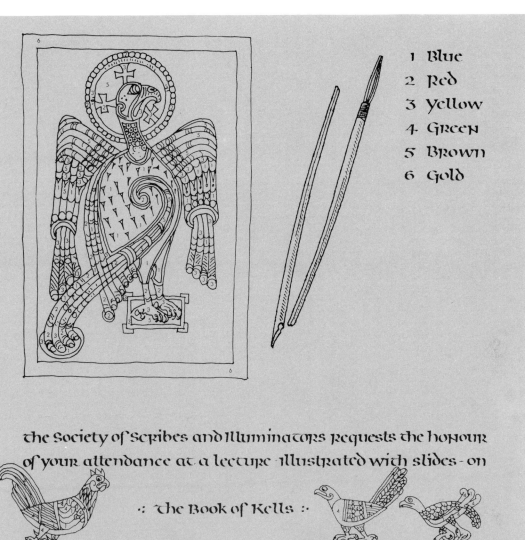

1 Blue
2 Red
3 Yellow
4 Green
5 Brown
6 Gold

the Society of Scribes and Illuminators requests the honour of your attendance at a lecture · illustrated with slides · on

∴ the Book of Kells ∴

by the Most Reverend G·O·Simms · Archbishop of Armagh on tuesday 27th March 1979 at 6·30 pm · doors open 6·15 · in the Lecture theatre · the Victoria & Albert Museum Cromwell Road · London · SW 7
the Chair will be taken by Mr · Ieuan Rees
R·S·V·P Mrs·S·Cavendish · hon Secretary
54 Boileau Road London SW13 9BL

Sydney Day
Invitation to a lecture on *The Book of Kells*. Actual printed size.

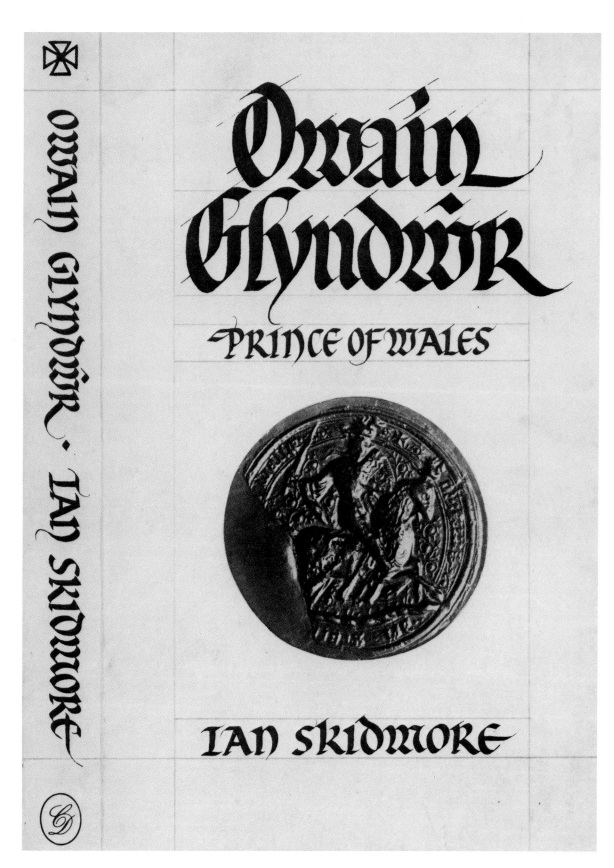

Ieuan Rees
Lettering for a bookjacket. Actual printed
size.

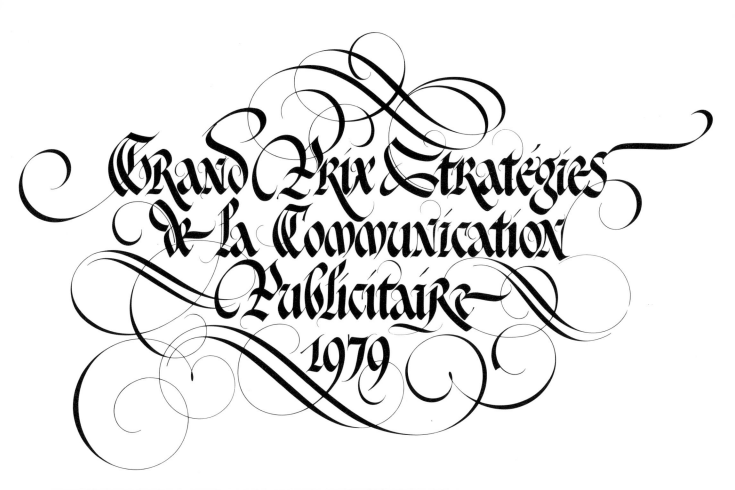

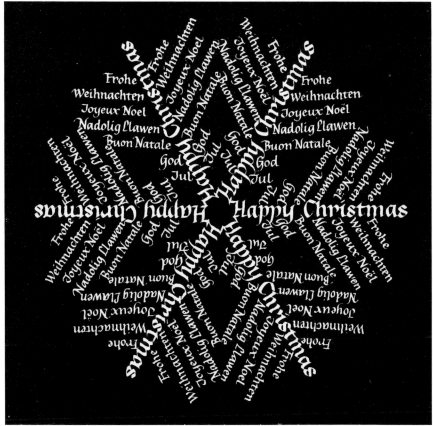

Claude Mediavilla
Calligraphy for a diploma. Original size
30 × 42 cm (12 × 16¾ in).

John Smith
Christmas greetings card. Actual printed
size

David Mekelburg

Calligraphy · Drawings · Serigraphs 11 March – 8 April 1978

Alphabets and names make games and everybody has a name and

ABCDEFG

all the same they have in a way to have a birthday. The thing to

HIJKLMN

do is to think of names...And you have to think of alphabets too,

OPQRST

without an alphabet well without names where are you and birthdays

UVWXYZ

are very favorable too, otherwise who are you. Everything begins with A.

GERTRUDE STEIN

India Ink Gallery

1231 Fourth Street · Santa Monica, California 90401 · (213) 393-2392

David Mekelburg
Exhibition poster printed in three colours.
Original written out on bond paper with
Automatic and Brause pens. Original and
printed size 60.9 × 45.7 cm (24 × 18 in).

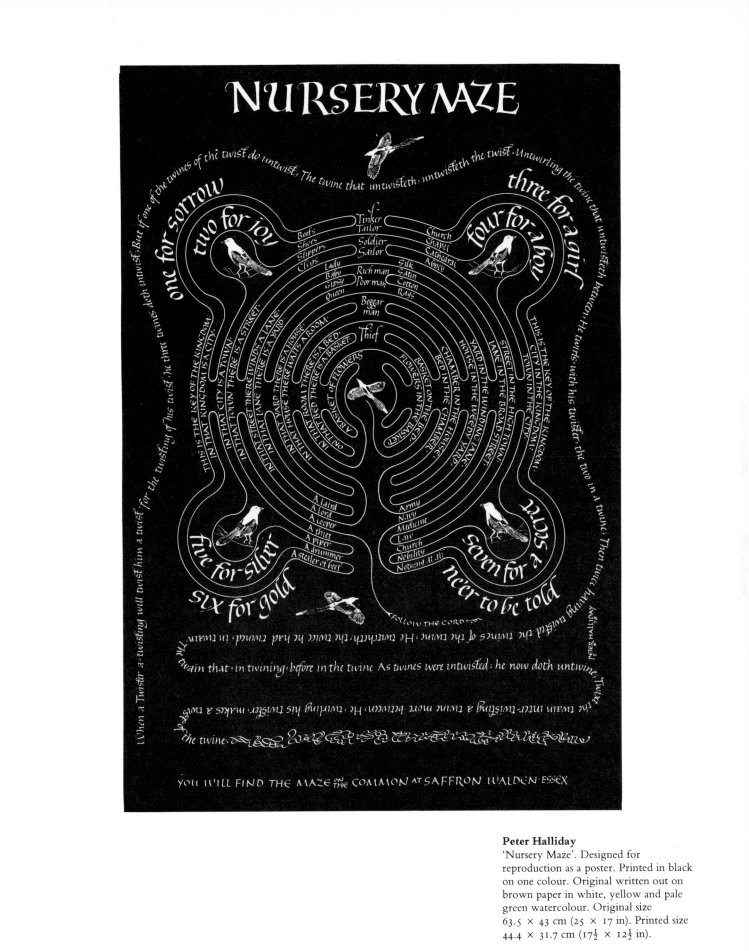

Peter Halliday
'Nursery Maze'. Designed for reproduction as a poster. Printed in black on one colour. Original written out on brown paper in white, yellow and pale green watercolour. Original size 63.5 × 43 cm (25 × 17 in). Printed size 44.4 × 31.7 cm (17½ × 12½ in).

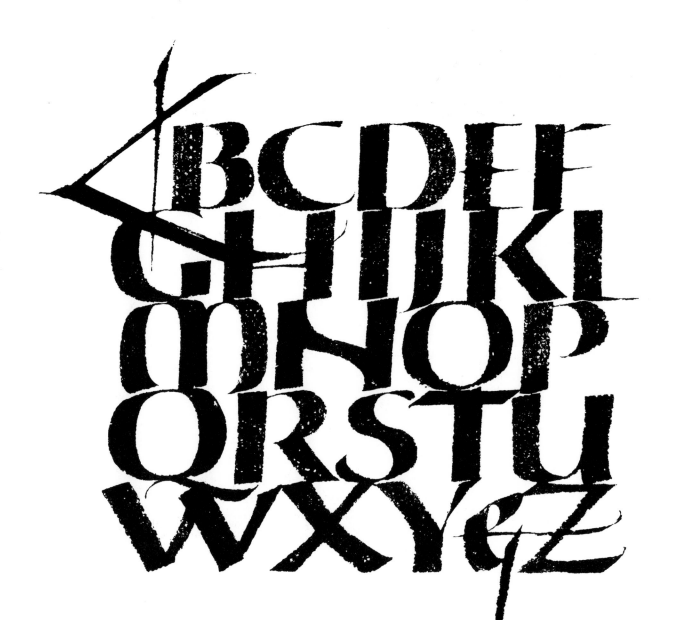

Letters are the key to our culture, they can also be a picklock to our heart.

BROR ZACHRISSON

Jacqueline Sakwa
Quotation from Hermann Zapf's *Manmade Typographicum* by Bror Zachrisson, 1954. Written out in dark green gouache on Bodleian hand-made paper. Original size 21.5 × 17.7 cm (8½ × 7 in).

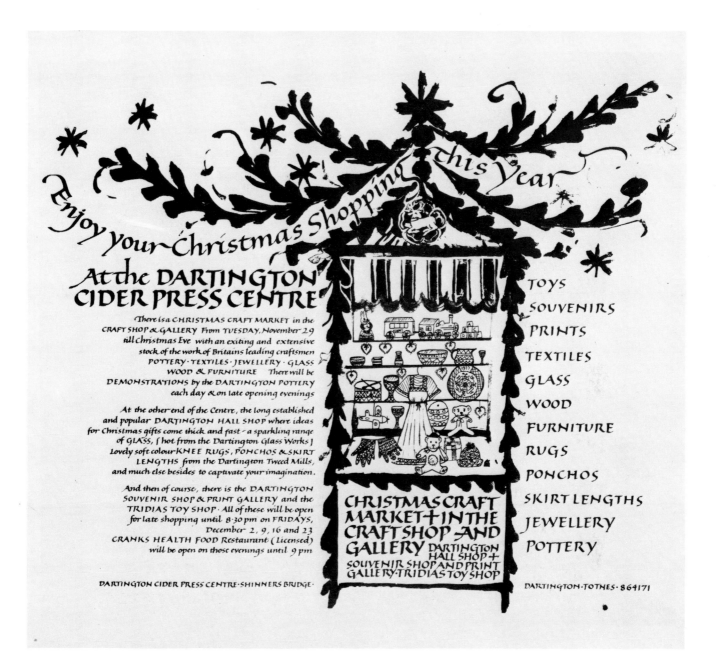

Donald Jackson
Christmas poster. Written out in black stick ink with brush, quill and steel pen on layout paper. Illustrations drawn by Kate Jackson. Height of original 36.7 cm (15 in).

Press advertisement. Written out in stick ink with quill on layout paper. Drawing by Kate and Morgan Jackson. Actual printed size.

Jean Larcher
Logotype for perfume packaging.

Patricia Weisberg
Cover of The Calligraphers' Engagement
Calendar 1979, published by Pentalic-
Taplinger, New York. Lettering in white
reversed out of red. The original was done
on bond paper with a Bouwsma pen and
touched up for reproduction.

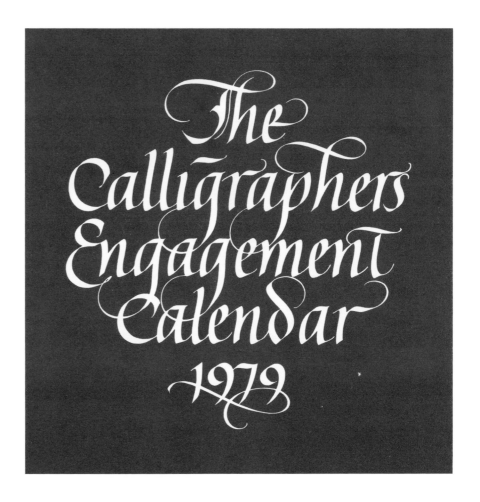

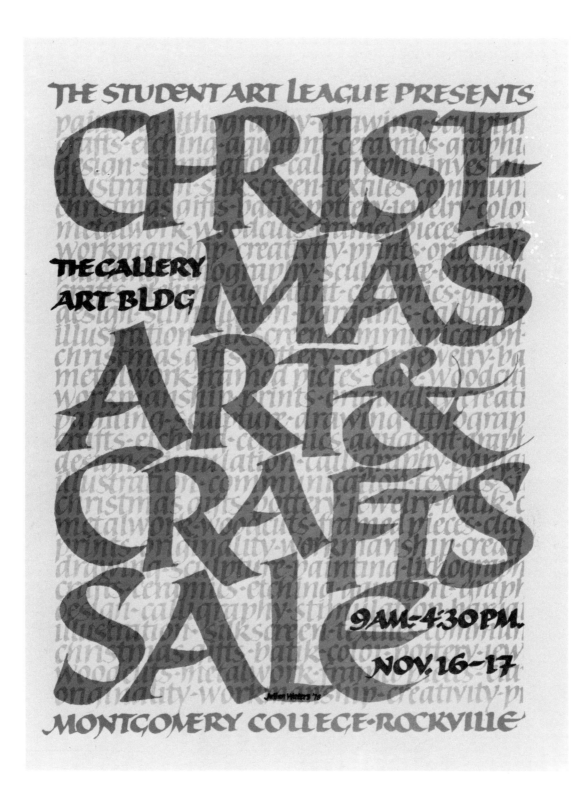

Julian Waters
Poster. Commissioned by Montgomery College, Maryland. Written out in Chinese stick ink with steel nibs and coit pen on hand-made paper. Original size 25 × 19 cm (9¾ × 7½ in).

Julian Waters
Quotation from Shakespeare, *The Tragedy of King Richard III*.I.I. Written out in Chinese stick ink with semi-flexible steel broad edged pens on rough handmade paper. The large capitals were written very small then enlarged photographically to exaggerate roughness. The small capitals were written large and reduced to exaggerate smoothness. Carried out for the 1980 Calligraphers' Engagement Calendar, published by Pentalic Taplinger.

Abigail Diamond Chapman
Calligraphy for the Pentalic-Taplinger Calendar 1979. Original size 21 × 22.8 cm (8¼ × 9 in). Printed size 16.7 × 19 cm (6½ × 7⅞ in).

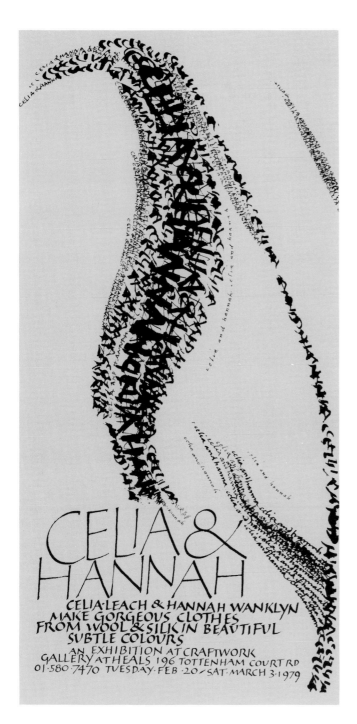

CELIA &
HANNAH
CELIA·LEACH & HANNAH WANKLYN
MAKE GORGEOUS CLOTHES
FROM WOOL & SILK IN BEAUTIFUL
SUBTLE COLOURS
AN EXHIBITION AT CRAFTWORK
GALLERY AT HEALS 196 TOTTENHAM COURT RD
01·580·7470 TUESDAY·FEB·20/SAT·MARCH 3·1979

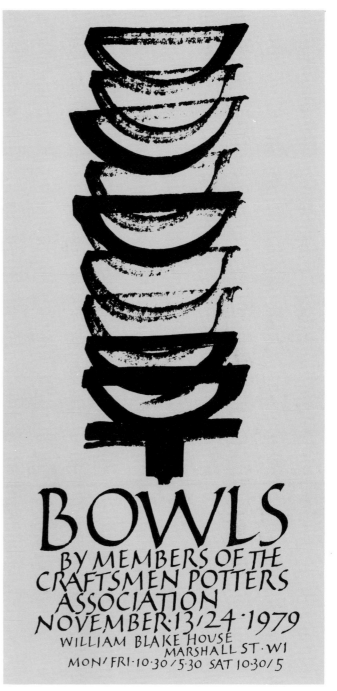

BOWLS
BY MEMBERS OF THE
CRAFTSMEN POTTERS
ASSOCIATION
NOVEMBER·13/24·1979
WILLIAM BLAKE HOUSE
MARSHALL ST·W1
MON/FRI·10·30/5·30 SAT 10·30/5

Donald Jackson
Invitation card 'Celia and Hannah'.
Written out in stick ink with quill pen on
layout paper. Original and printed size
21 × 10.4 cm (8¼ × 4⅛ in).

Invitation card 'Bowls'. Written out in
stick ink, felt tip pen and quills on layout
paper. Original and printed size
22.2 × 10.4 cm (8¾ × 4⅛ in).

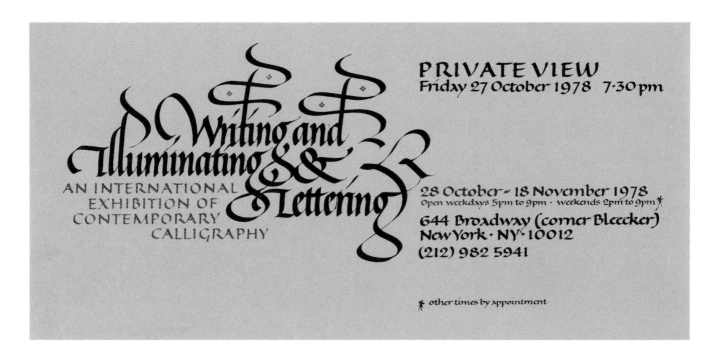

Charles Pearce
Invitation. Printed size 10.3 × 23.2 cm
(4 × 9⅛ in).

David Graham
Embossed menu cover for luncheon held
in honour of the Royal visit to the Royal
Maundy Service at Winchester Cathedral,
in its 900th anniversary year. Size of menu
24 × 19 cm (9⅞ × 7⅜ in).
Courtesy of the Hampshire County Council.

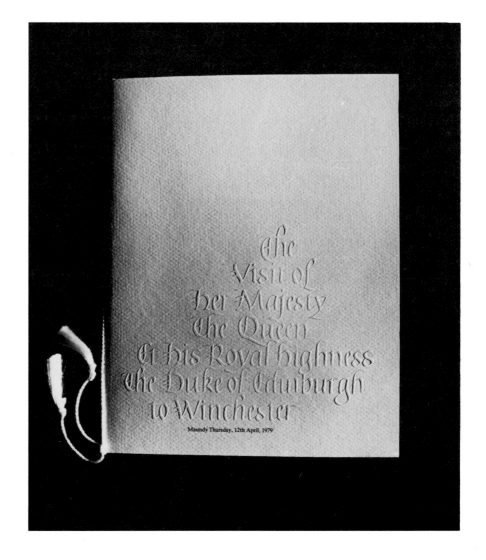

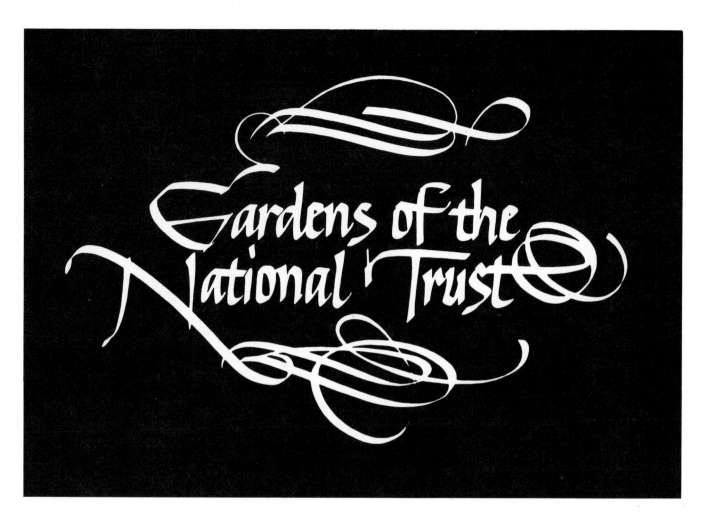

David Howells
Lettering for cover of National Trust
Calendar.

Donald Jackson
Emblem for use on stationary, flags and
Tee-shirts.

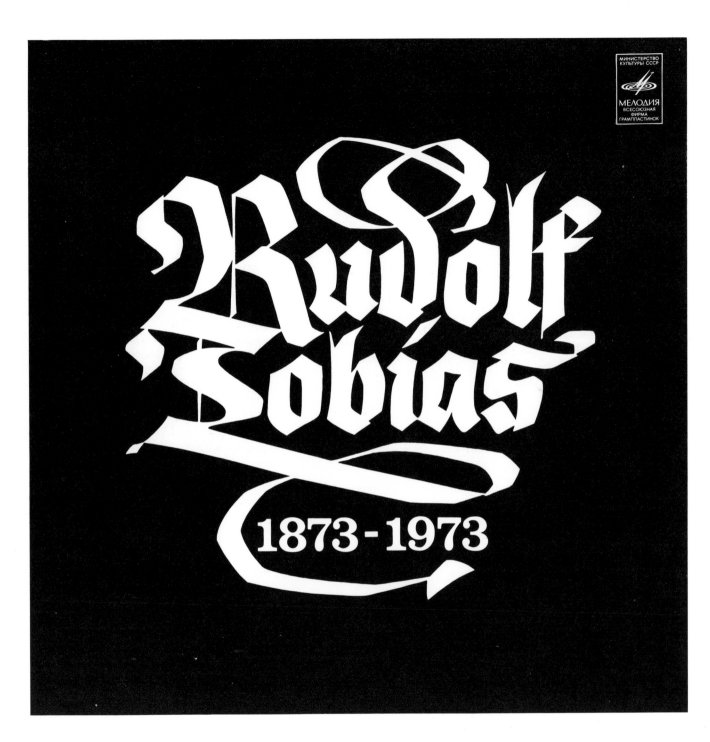

Villu Toots
Design for a record sleeve.

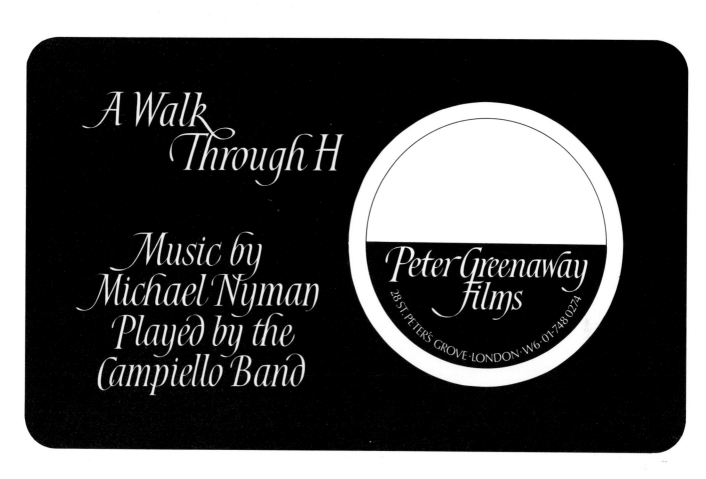

A Walk Through H

Music by Michael Nyman Played by the Campiello Band

Peter Greenaway Films
28 ST. PETER'S GROVE · LONDON · W6 · 01-748 0274

Kenneth Breese
Film can label and film titles in brush lettering for Peter Greenaway Films.

Brian P Clare
Logotype designed for the National Commission on the Cost of Medical Care. Original size 15×26.2 cm ($6 \times 10\frac{1}{2}$ in).

NATIONAL COMMISSION ON THE COST OF MEDICAL CARE

David Quay
Logotype designed for Penguin Books.
Original artwork lettered to a width of
20.3 cm (8 in).

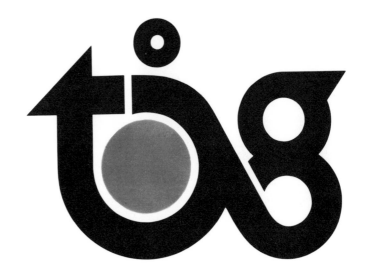

Lars Jonsson
Logotype for Swedish rail road
newspaper.

Lars Jonsson
Logotype for a Stockholm gym school.
Award winner in the Type Directors Club
Competition, New York, 1979.

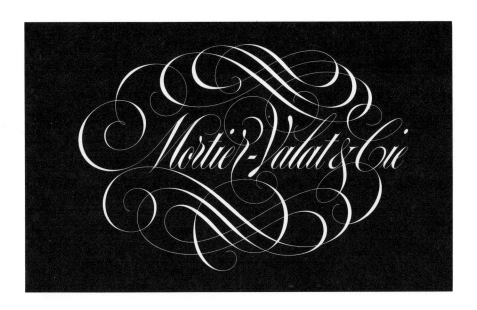

Claude Mediavilla
Logotype designed for an art gallery.

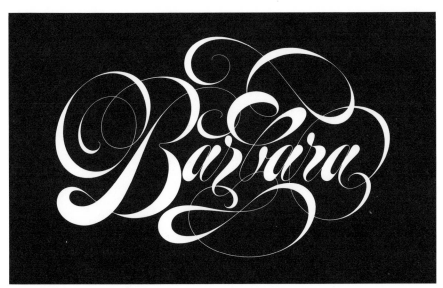

Tony Di Spigna
Design for personal stationery.

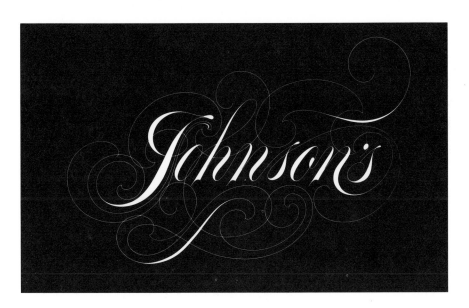

Tony Di Spigna
Part of a corporate identity for Johnson's
Sanitation, Minnesota.

I AM A JEW. HATH NOT A JEW EYES?

HATH NOT A JEW HANDS, ORGANS, DIMENSIONS, SENSES, AFFECTIONS, PASSIONS? FED WITH THE SAME FOOD, HURT WITH THE SAME WEAPONS, SUBJECT TO THE SAME DISEASES, HEALED BY THE SAME MEANS,

WARMED AND COOLED BY THE SAME WINTER AND SUMMER AS

A CHRISTIAN IS? IF YOU PRICK US, DO WE NOT BLEED? IF YOU TICKLE

US, DO WE NOT LAUGH? IF YOU POISON US, DO WE NOT DIE? AND IF YOU WRONG US, SHALL WE NOT REVENGE? IF WE ARE LIKE YOU IN

THE REST, WILL RESEMBLE YOU IN THAT.

SHYLOCK · THE MERCHANT OF VENICE · ACT III SCENE I

Abigail Diamond Chapman
Calligraphy for the Pentalic-Taplinger
Calendar 1979. Original size 55.8 ×
43.1 cm (22 × 17 in). Printed size 16.7 ×
14.6 cm (6½ × 5⅞ in).

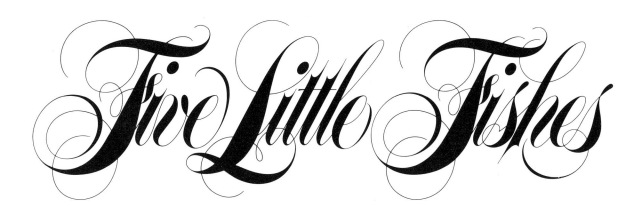

Jean Larcher
Logotype for an advertising studio in
Paris, Five Little Fishes. Art director:
Franck Vardon. Original drawn on
scratchboard 18 × 61 cm (7 × 23¾ in).

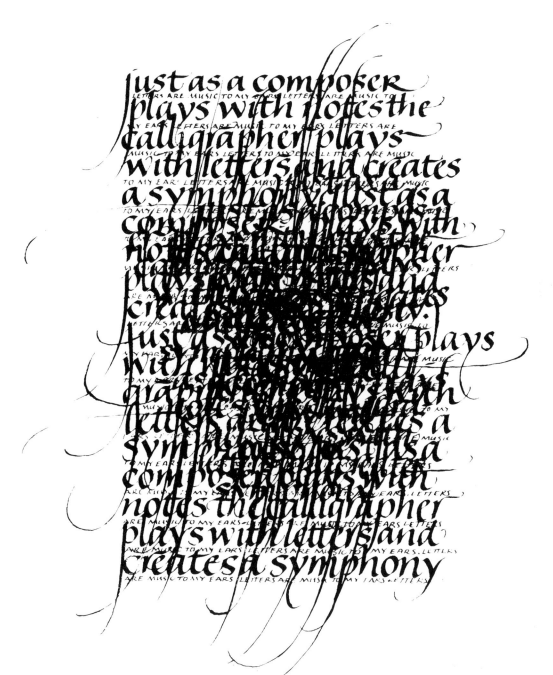

just as a composer
plays with notes the
calligrapher plays
with letters and creates
a symphony. just as a
composer plays with
notes the calligrapher
plays with letters and
creates a symphony.
just as a composer plays
with notes the calli-
grapher plays with
letters and creates a
symphony. just as a
composer plays with
notes the calligrapher
plays with letters and
creates a symphony

Mary Quinault Kossakowski
With the theme of 'Creativity' this piece
represents an attempt to recreate in letter
forms the feeling of a symphony in
calligraphy thus combining the visual with
audio expression in the arts. Designed for
The Society of Scribes 1979 Calendar.
Written out in Higgins Eternal ink with
two Mitchell broad-edge pens on
Strathmore paper.

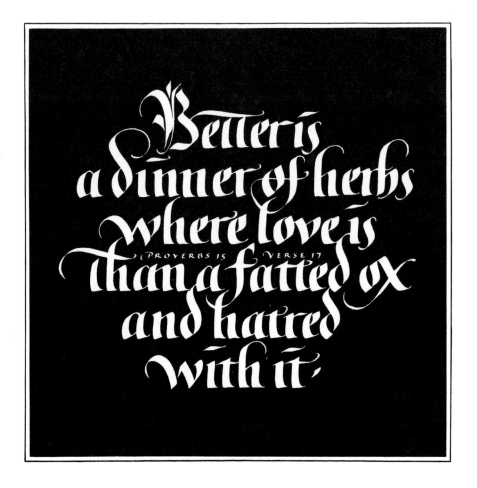

The poulterers' shops were still half open and the fruiterers were radiant in their glory. There were great, round, pot-bellied baskets of chestnuts, shaped like the waistcoats of jolly old gentlemen, lolling at the doors, and tumbling out into the street in their apoplectic opulence. There were ruddy, brown-faced, broad-girthed Spanish Onions, shining in the fatness of their growth like Spanish Friars, and winking from their shelves in wanton slyness at the girls as they went by, and glanced demurely at the hung-up mistletoe. There were pears and apples, clustered high in blooming pyramids; there were bunches of grapes, made, in the shopkeepers' benevolence, to dangle from conspicuous hooks, that people's mouths might water gratis as they passed.

Charles Dickens "A Christmas Carol"

Eleanor Winters
Christmas greetings card. Illustration by
Linda Dannhauser.

Patricia Weisberg
Calligraphy for the Pentalic-Taplinger
Calendar 1979.

Better is a dinner of herbs where love is (PROVERBS 15 VERSE 17) than a fatted ox and hatred with it.

124

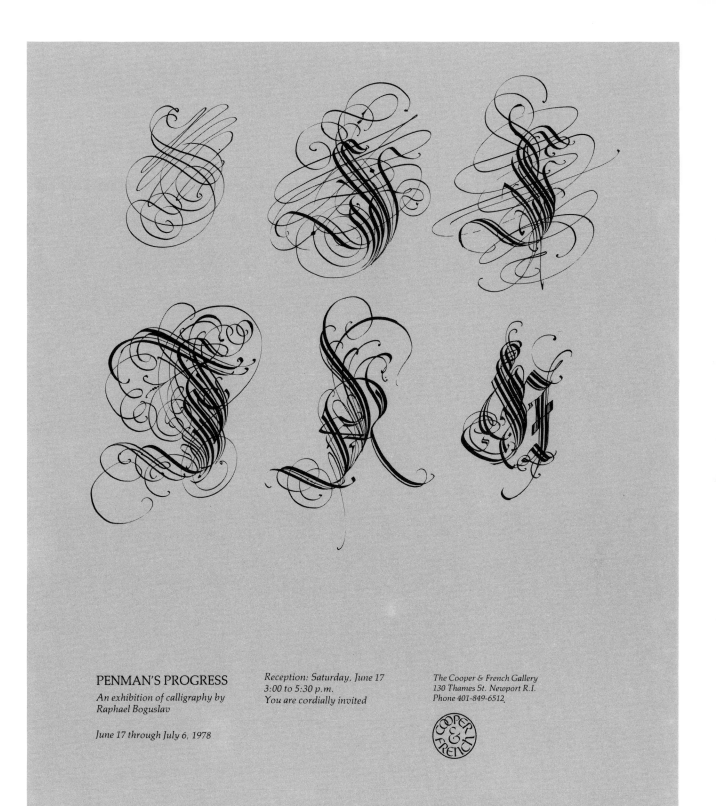

PENMAN'S PROGRESS

*An exhibition of calligraphy by
Raphael Boguslav*

June 17 through July 6, 1978

*Reception: Saturday, June 17
3:00 to 5:30 p.m.
You are cordially invited*

*The Cooper & French Gallery
130 Thames St. Newport R.I.
Phone 401-849-6512*

Raphael Boguslav
Exhibition poster. Printed size
35.5 × 28 cm (14 × 11 in).

MANY MERRY CHRISTMASSES, FRIENDSHIPS,

EXTRACTS FROM CHARLES DICKENS
Design by D·Howells & G·Percival 1978

GREAT ACCUMULATION OF CHEERFUL RECOLLECTIONS, AFFECTION ON EARTH, AND HEAVEN AT LAST·FOR ALL OF US.

In came a fiddler with a music book; and went up to the lofty desk, and made an orchestra of it, and tuned like fifty stomach-aches. In came Mrs. Fezziwig, one vast substantial smile. In came the three Miss Fezziwigs, beaming and lovable. In came the six young followers whose hearts they broke. In came all the young men & women employed in the business. In came the house-maid, with her cousin, the baker. In came the cook with her brother's particular friend, the milkman. In came the boy from over the way, who was suspected of not having board enough from his master; trying to hide himself behind the girl from next door but one, who was proved to have had her ears pulled by her mistress. In they all came, one after another; some shyly, some boldly, some

Such a bustle ensued that you might have thought a goose the rarest of all birds; a feathered phenom-enon, to which a black swan was a matter of course—and in truth it was something very like it in that house! Mrs. Cratchit made the gravy (ready beforehand in a little saucepan) hissing hot; Master Peter mashed the pot-atoes with incredible vigour; Miss Belinda sweetened up the apple-sauce; Martha dusted the hot plates; Bob took Tiny Tim beside him in a tiny corner at the table; the two young Cratchits set chairs for everybody, not forgetting themselves, and mount-ing guard upon their posts, cram-med spoons into their mouths.

David Howells and G Percival
Christmas greetings card printed in gold, blue and red. Illustrated here are both sides of card. Printed size 10 × 21.8 cm (4 × 8¼ in).

Inscriptional lettering

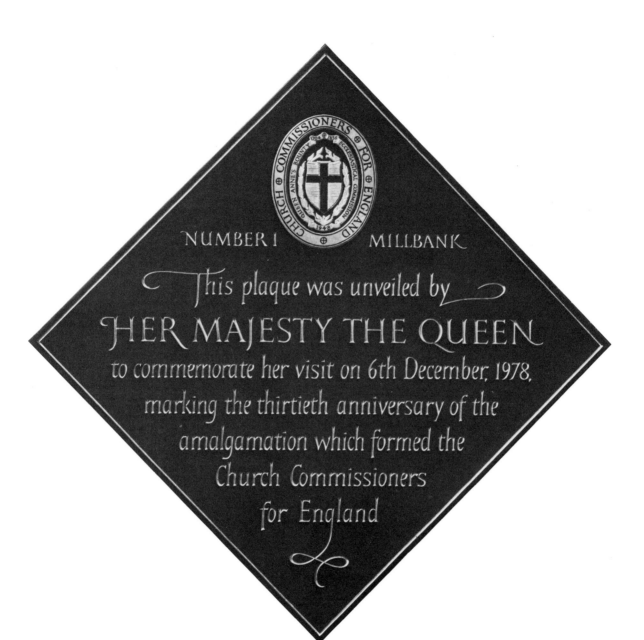

David Dewey
Commemorative plaque. Blue grey slate.
45.7 × 45.7 cm (18 × 18 in).

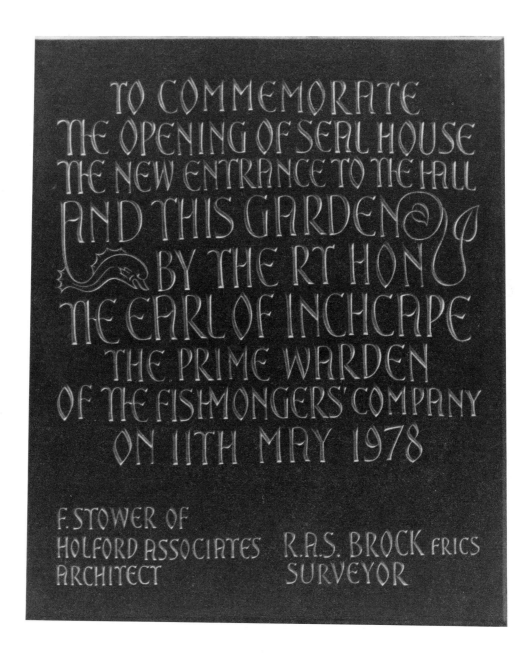

TO COMMEMORATE
THE OPENING OF SEAL HOUSE
THE NEW ENTRANCE TO THE HALL
AND THIS GARDEN
BY THE RT HON
THE EARL OF INCHCAPE
THE PRIME WARDEN
OF THE FISHMONGERS' COMPANY
ON 11TH MAY 1978

F. STOWER OF
HOLFORD ASSOCIATES
ARCHITECT

R.A.S. BROCK FRICS
SURVEYOR

Richard Kindersley
Commemorative plaque commissioned by
The Fishmonger's Company. Carved
Welsh slate. 58 × 46 cm (22½ × 18 in)

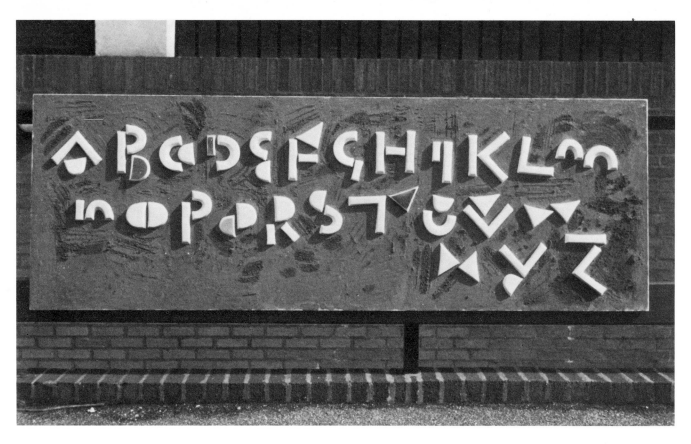

David Howells
Modular alphabet. Slip-cast ceramic units
glazed and fixed to a wooden board with
sand-textured surface. 76 cm × 2.1 m
(2 ft 6 in × 7 ft).

Richard Kindersley
Commemorative plaque commissioned by
the Manchester Hospital Board. Carved
Welsh slate. Diameter 66 cm (25¾ in).

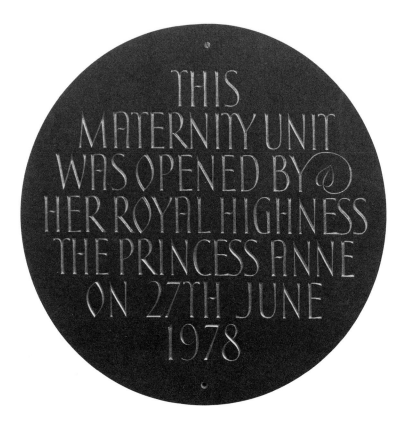

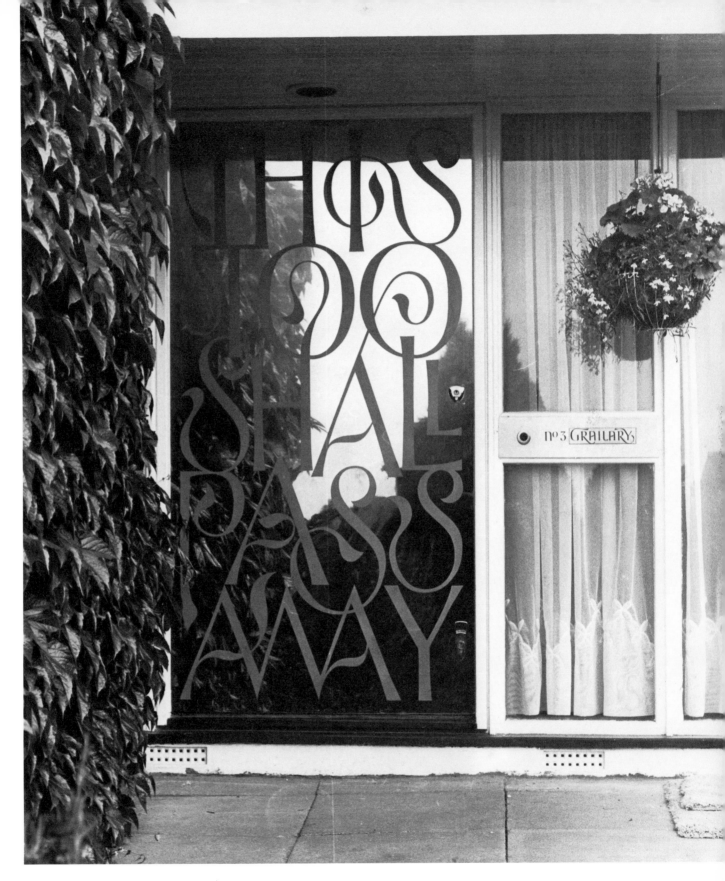

Richard Kindersley
Sand blast stainless steel door.

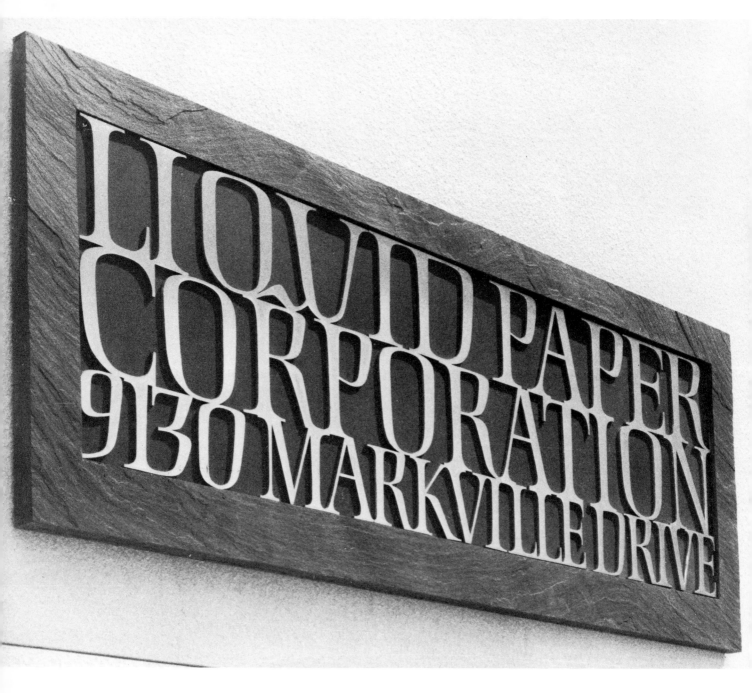

John Skelton
Sign for the Liquid Paper Corporation,
Dallas, Texas. Riven Buckingham slate.
Brass letters with chrome satin finish.
Length 3.2 m (10 ft 6 in).

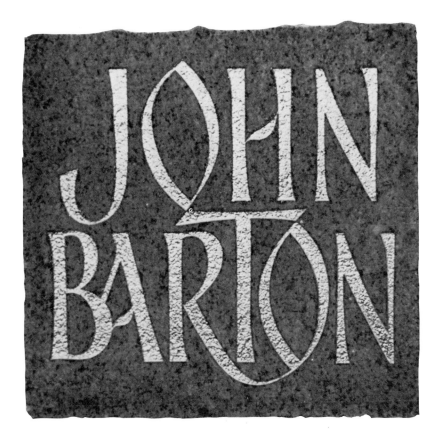

Richard Kindersley
Raised lettering in plaster, stained yellow
ochre. 1.3 × 2 m (40 × 78 in).

Sand blast granite, gilded. 30 cm sq
(11¾ in sq).

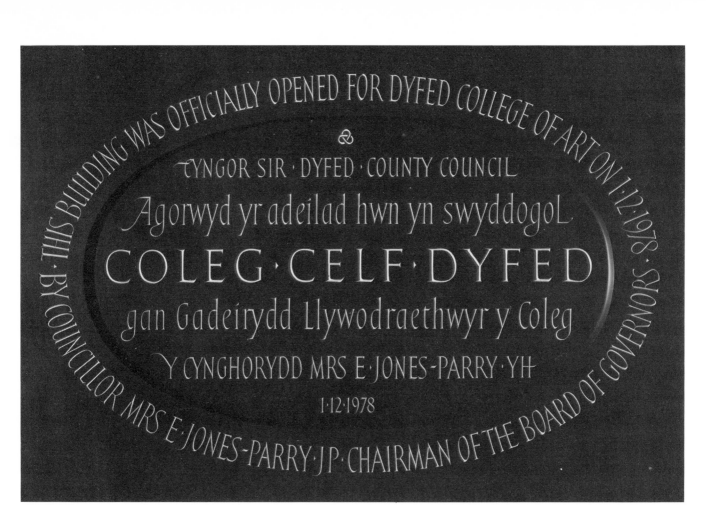

Ieuan Rees
Commemorative plaque for Dyfed
College of Art, Carmarthen. Welsh slate
with sunken oval.

Donald Jackson
Sign of window commissioned by Cranks
Health Foods. Brush painted in
signwriter's enamel. Breadth 61 cm
(24 in). *Courtesy Cranks Health Foods.*

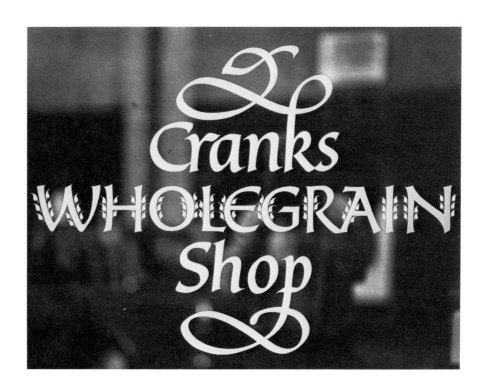

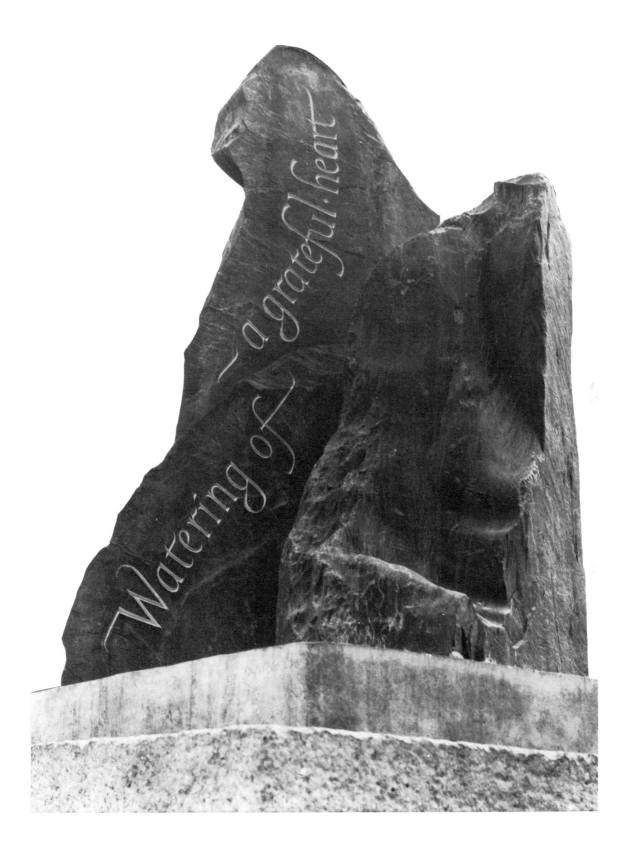

Ieuan Rees
Inscription on two boulders from Penrhyn Quarry, North Wales. Presented to the Borough of Brent, London. Height of tallest boulder approximately 2.4 m (8 ft).

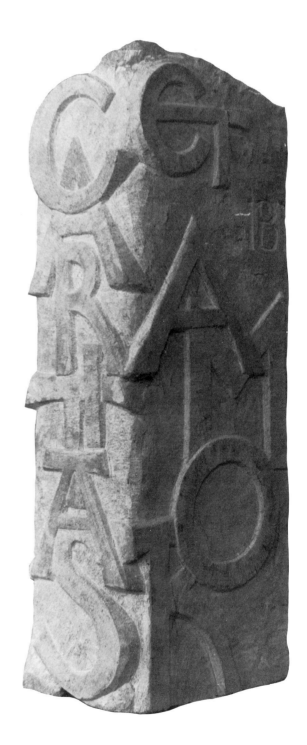

**LORD THOMSON
OF FLEET
1894-1976**

*He gave a new direction
to the British newspaper
industry. A strange and
adventurous man from
nowhere, ennobled by the
great virtues of courage
and integrity and
faithfulness*

David Kindersley
Commemorative plaque. Welsh slate, cut
by Kevin Cribb. 99 × 66 cm (39 × 26 in).

Nicolete Gray
Raised letters. Portland stone.

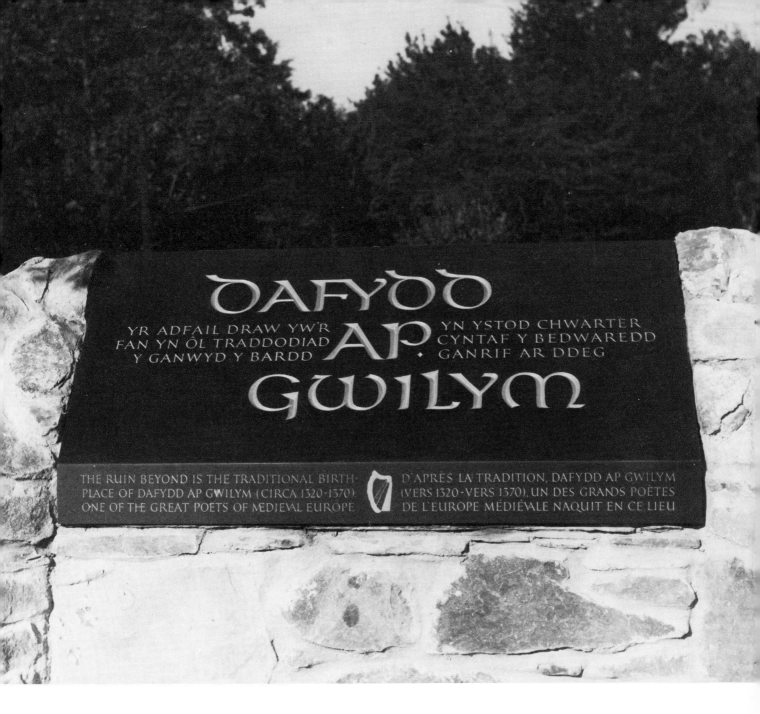

DAFYDD AP GWILYM

YR ADFAIL DRAW YW'R
FAN YN ÔL TRADDODIAD
Y GANWYD Y BARDD

YN YSTOD CHWARTER
CYNTAF Y BEDWAREDD
GANRIF AR DDEG

THE RUIN BEYOND IS THE TRADITIONAL BIRTH-
PLACE OF DAFYDD AP GWILYM (CIRCA 1320-1370)
ONE OF THE GREAT POETS OF MEDIEVAL EUROPE

D'APRÈS LA TRADITION, DAFYDD AP GWILYM
(VERS 1320-VERS 1370), UN DES GRANDS POÈTES
DE L'EUROPE MÉDIÉVALE NAQUIT EN CE LIEU

Ieuan Rees
Inscription in Welsh, English and French.
Welsh blue slate. 88.8 × 127 cm
(1 ft 11 in × 4 ft 2 in).

Lida Lopes Cardozo
Engraved glass roundel. Exhibition piece.

Engraved glass decanter commissioned as a wedding present for Mr and Mrs David Jenkins of Oxford. Approximate height 22.8 cm (9 in).

David Kindersley
Rustic Roman letters. Kelton stone, cut
by Lida Lopes Cardozo. 71 × 30.4 cm
(28 × 20 in).

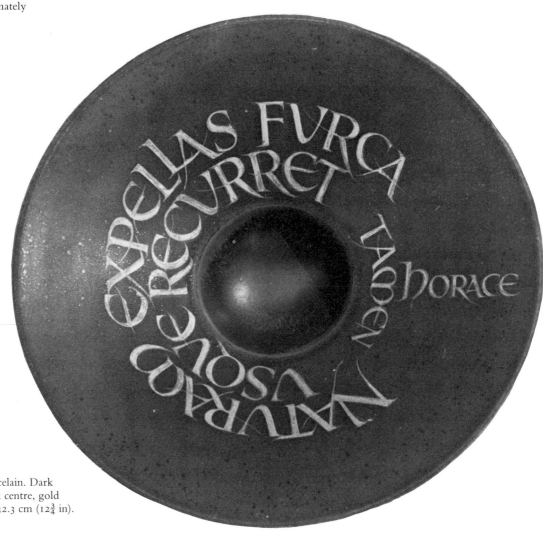

David Kindersley
'Tentoonstelling'. Mansfield limestone, cut
by Kevin Cribb. Approximately
15.2 × 66 cm (6 × 26 in).

Mary White
Wide flanged bowl in porcelain. Dark
green crystally glaze, black centre, gold
lustre lettering. Diameter 32.3 cm (12¾ in).

DER STADT
KEMPEN
ÜBERREICHT
AUS ANLASS
DER STÄDTE·
PARTNERSCHAFT
KEMPEN·EAST
CAMBRIDGE·
SHIRE

David Peace
Vase engraved in 1978 to mark the
twinning of the two local authorities, East
Cambridgeshire District Council and
Kempen, West Germany. Commissioned
by East Cambridge District Council.
Height 17.7 cm (7 in).

David Peace
Glass bowl engraved with the lettering 'All embodied labour should be kept in reverence'. Diameter 30.4 cm (12 in).

David Kindersley
Engraved glass. Cut by Mark Bury. (26 × 18 in)

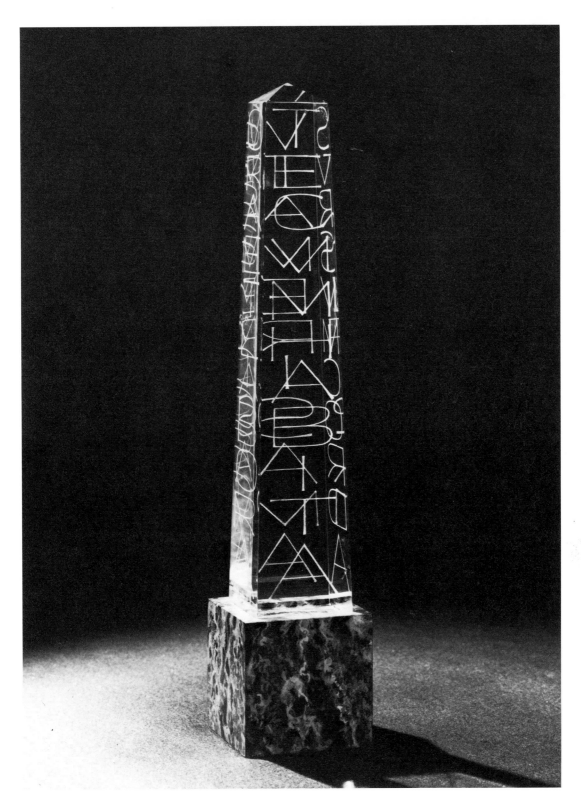

David Peace
Glass obelisk engraved with four Latin
mottoes each of 11 letters ending in 'A':
*Ora et Labora; Sursum Corda; Tecum
Habita; Ut Ameris Ama.* Overall height
including marble base 30.4 cm (12 in).

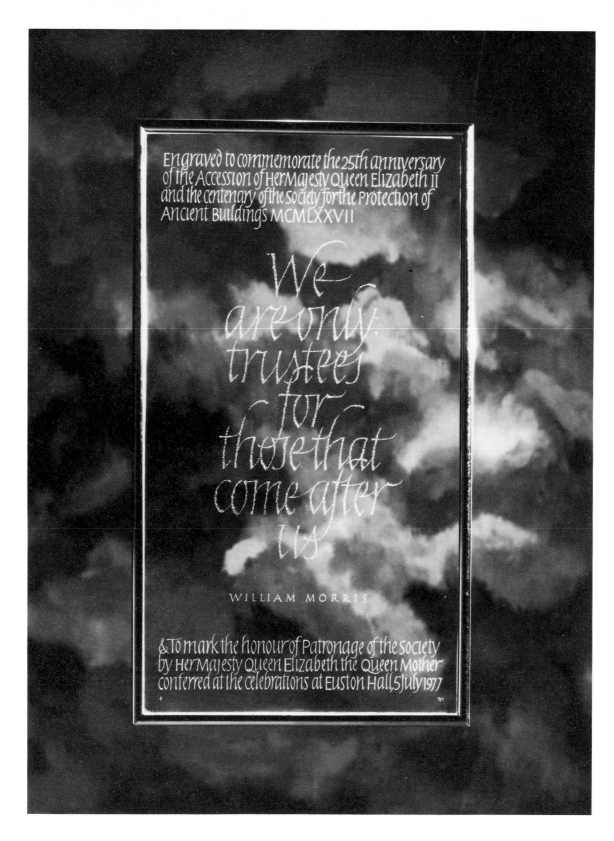

Engraved to commemorate the 25th anniversary
of the Accession of Her Majesty Queen Elizabeth II
and the centenary of the Society for the Protection of
Ancient Buildings MCMLXXVII

*We
are only
trustees
for
those that
come after
us*

WILLIAM MORRIS

& To mark the honour of Patronage of the society
by Her Majesty Queen Elizabeth the Queen Mother
conferred at the celebrations at Euston Hall, 5 July 1977

David Peace
Window pane engraved for the
committee room of the Society for the
protection of Ancient Buildings.

David Dewey
Name plaque for Oxford County Museum. Slate. 61 × 126 cm (23¾ × 49 in).

John Skelton
Plaque. Welsh slate. Diameter 50.8 cm (20 in).

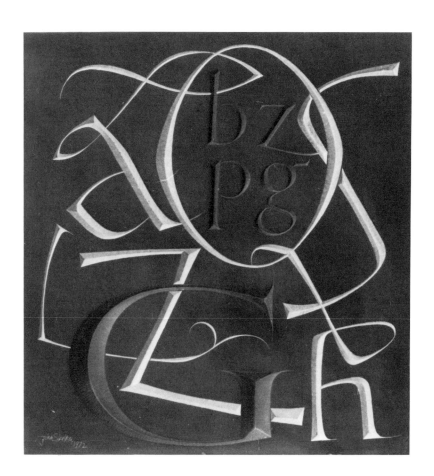

John Skelton
Lettering sample. Slate. 22.8 cm sq
(3 ft 6 in).

David Dewey
Slate sign incised and coloured.
69.8 × 61 cm (27½ × 24 in).

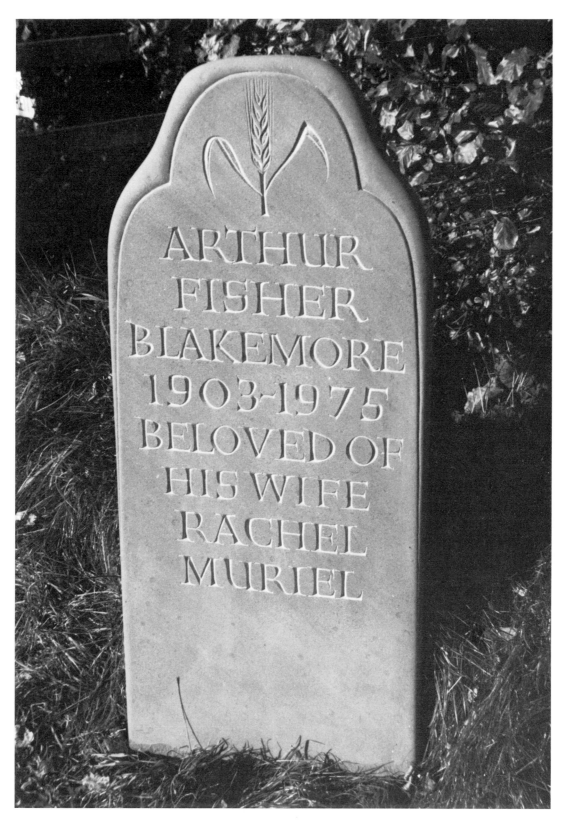

John Skelton
Headstone. Red sandstone. Height 1.6 m
(3 ft 6 in).

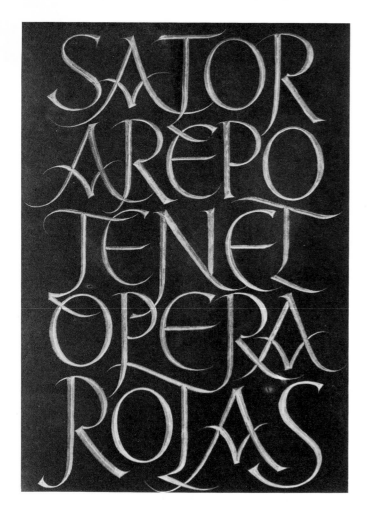

Harry Meadows
Latin inscription cut in slate.
51 × 30.5 cm (20 × 12 in).

Thomas Perkins
Latin inscription cut in Yorkstone.
Original size 81.2 × 32.3 cm
(32 × 12¾ in).

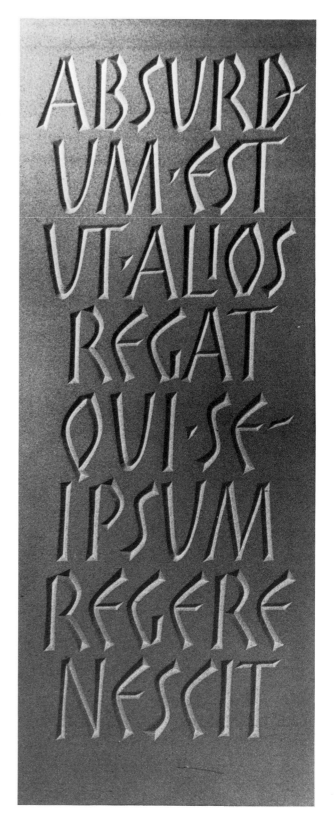

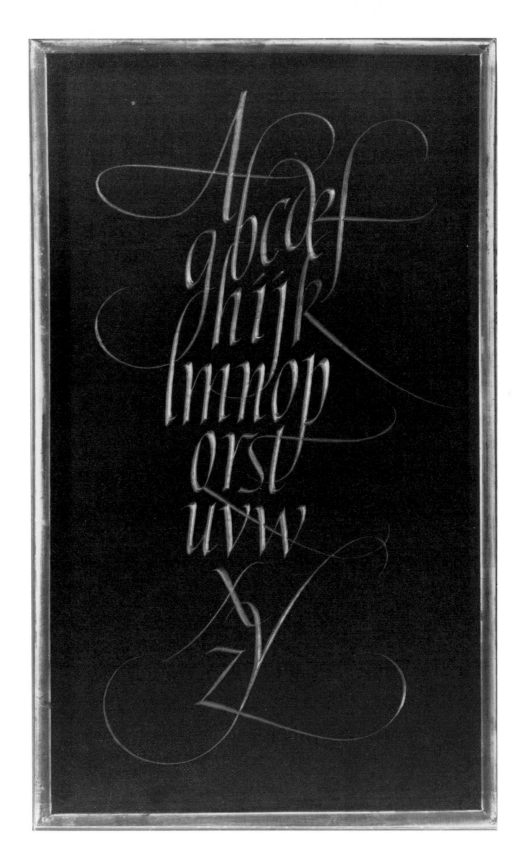

Guillermo Rodriguez-Benitez
Italic alphabet cut in slate.

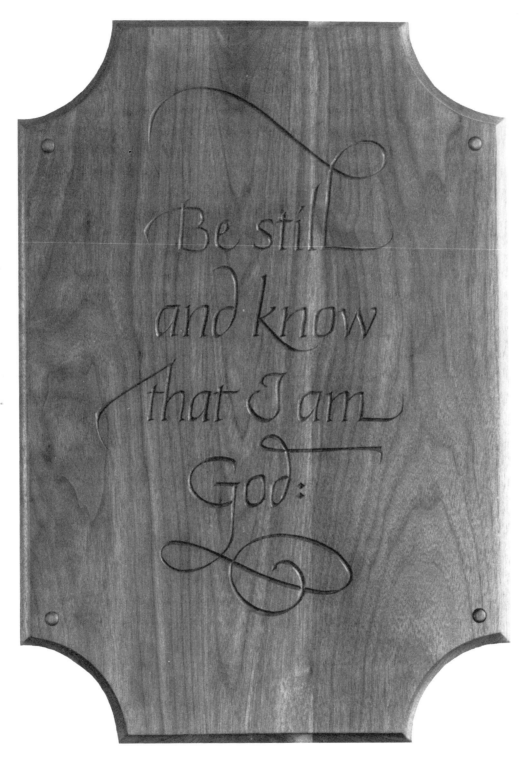

Michael W Hughey
Plaque commissioned by a Church.
American Walnut. 66 × 47.7 cm
(26. × 18 in)

la stampa
nõ poſsa in tutto
ripreſentarte la
Viva mano

John E Benson
Black slate, V-cut gilded letters.
21 × 28.5 cm (8½ × 11¾ in).

John Woodcock
Rings in matching box with engraved lid in silver.

Raymond Gid
'Semaine Sainte'. Medal minted by the
Monnaie de Paris. Both sides shown at
actual size.

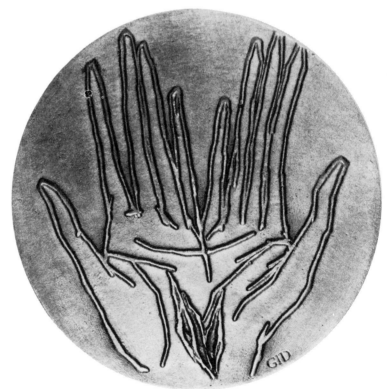

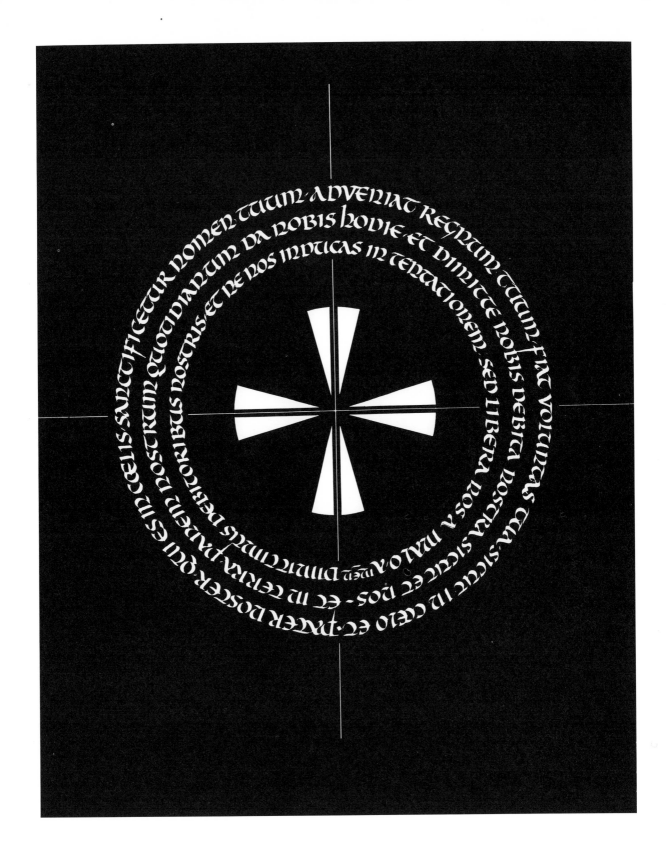

George Thomson
Lord's Prayer. Lettering photo-etched in
brass. 25 × 25 cm (9¾ × 9¾ in).

Raymond Gid
'À la Calligraphie Renaissante'. To be
minted as a medal in 1980. Actual size.

'Célébration de la lettre'. Medal minted by
the Monnaie de Paris. Diameter 13.3 cm
(5¼ in).

DO NOT ALL CHARMS FLY
AT THE MERE TOUCH OF
COLD PHILOSOPHY?
THERE WAS AN AWFUL
RAINBOW ONCE IN HEAV-
EN: WE KNEW HER WOOF
& TEXTURE, SHE is GIVEN
IN THE DULL CATALOGUE
OF COMMON THINGS

David Kindersley
Plaque engraved with a quotation from
Keats' *Lamia*. Mansfield limestone, cut by
Lida Lopes Cardozo. 73.6 × 48.2 cm
(29 × 19 in).

John E Benson
Black slate, V-cut gilded letters.
70 × 41.2 cm (24 × 16¼ in).

Index of calligraphers

Full addresses of societies or services through which individual
artists can be contacted are given on pages 159–160

Alexander, Irene (Canada) 93
Society of Scribes & Illuminators, London

Alice (U.S.A.) 84
Society of Scribes, New York

Angel, Marie (U.K.) 98, 99
Society of Scribes & Illuminators, London

Avery, Dorothy (U.K.) 81
Society of Scribes & Illuminators, London

Baker, Arthur (U.S.A.) 40, 47
Calligraphy Space 2001, New York

Barrie, Stuart (U.K.) 50
Society of Scribes & Illuminators, London

Basu, Hella (U.K.) 31
Society of Scribes & Illuminators, London

Benedict, Anne (U.S.A.) 50
Society of Scribes, New York

Benson, John E (U.S.A.) 74, 151, 156
Calligraphy Space 2001, New York

Berndal, Bo (Sweden) 92, 94
Society of Scribes & Illuminators, London

Boguslav, Raphael (U.S.A.) 18, 21, 23
Calligraphy Space 2001, New York

Boyajian, Robert (U.S.A.) 46
Calligraphy Space 2001, New York

Breese, Kenneth (U.K.) 71, 92, 119
Society of Scribes & Illuminators, London

Christensen, Linda (U.S.A.) 74
The Colleagues of Calligraphy, St Paul,
MINN

Clare, Brian P (U.S.A.) 119
Chicago Calligraphy Collective, Chicago

Colleen (U.S.A.) 60
Lettering Arts Guild of Boston

Cooper Barnard, Maura (U.S.A.) 78
Society of Scribes & Illuminators, London

Culmone, Nancy (U.S.A.) 42, 44
Calligraphy Space 2001, New York

David, Ismar (U.S.A.) 97, 98
Calligraphy Space 2001, New York

Day, Sydney (U.K.) 105
Society of Scribes & Illuminators, London

Dewey, David (U.K.) 128, 145, 146
Society of Scribes & Illuminators, London

Diamond Chapman, Abigail (U.S.A.) 114, 122
Society of Scribes, New York

Dieterich, Claude (Peru) 17, 48
Society of Scribes & Illuminators, London

Di Spigna, Tony (U.S.A.) 121
Calligraphy Space 2001, New York

Dunham, Ward (U.S.A.) 81, 45
Society of Scribes, New York

Evans, Jean (U.S.A.) 10, 24, 54, 62
Calligraphy Space 2001, New York

Fleuss, Gerry (U.K.) 92
Society of Scribes & Illuminators, London

Freeman, Paul (U.S.A.) 43
Society of Scribes, New York

Gatti, David (U.S.A.) 88
Society of Scribes, New York

Gid, Raymond (France) 152, 154
Society of Scribes & Illuminators, London

Goldberg Marks, Cara (U.S.A.) 59
Society of Scribes, New York

Graham, David (U.K.) 72, 116
Society of Scribes & Illuminators, London

Gray, Nicolete (U.K.) 136
Society of Scribes & Illuminators, London

Gullick, Michael (U.K.) 101
Society of Scribes & Illuminators, London

Halliday, Peter (U.K.) 54, 69, 104, 109
Society of Scribes & Illuminators, London

Hayes, James (U.S.A.) 103
Calligraphy Space 2001, New York

Hechle, Ann (U.K.) 30, 62
Society of Scribes & Illuminators, London

Howells, David (U.K.) 117, 126, 130
Society of Scribes & Illuminators, London

Hughey, Michael W (U.S.A.) 150
The Lettering Arts Association, Asheville,
NC

Ibbett, Vera (U.K.) 75
Society of Scribes & Illuminators, London

Jackson, Donald (U.K.) 53, 55, 58, 69, 73,
93, 111, 115, 117, 134
Society of Scribes & Illuminators, London

Jackson, Martin (Canada) jacket illustration
Society of Scribes & Illuminators, London

Jonsson, Lars (Sweden) 120
Society of Scribes & Illuminators, London

Karl, Anita (U.S.A.) 89
Society of Scribes, New York

Kelly, Jerry (U.S.A.) 14, 48, 51
Calligraphy Space 2001, New York

Kindersley, David (U.K.) 90, 136, 155,
142
Society of Scribes & Illuminators, London

Kindersley, Richard (U.K.) 129, 130, 131,
133, 137
Society of Scribes & Illuminators, London

Knight, Stanley (U.K.) 10, 13, 22, 59
Society of Scribes & Illuminators, London

Larcher, Jean (France) 98
Society of Scribes & Illuminators, London

Linz, Alfred (Germany) 20, 23, 28
Society of Scribes & Illuminators, London

Lopes Cardozo, Lida (U.K.) 92, 138
Society of Scribes & Illuminators, London

Maurer, Paul (U.S.A.) 26, 27
Calligraphy Space 2001, New York

McFarland, James W. (U.S.A.) 24
Society of Scribes, New York

Meadows, Harry (U.K.) 148
Society of Scribes & Illuminators, London

Mediavilla, Claude (France) 20, 107, 121
Society of Scribes & Illuminators, London

Mekelburg, David (U.S.A.) 49, 52, 85,
89, 108
Society for Calligraphers, Los Angeles

Metzig, William (U.S.A.) 15, 76
Calligraphy Space 2001, New York

Morris, I (U.K.) 32
Society of Scribes & Illuminators, London

Nasser, Muriel (U.S.A.) 93
Society of Scribes, New York

Neugebauer, Friederich (Germany) 95
Society of Scribes & Illuminators, London

Peace, David (U.K.) 142, 143, 144
Society of Scribes & Illuminators, London

Pearce, Charles (U.K.) 11, 19, 35, 69,
116
Calligraphy Space 2001, New York

Perkins, Thomas (U.K.) 148
Society of Scribes & Illuminators, London

Pilsbury, Joan (U.K.) 38, 75
Society of Scribes & Illuminators, London

Prestianni, John (U.S.A.) 36, 37, 96
Friends of Calligraphy, San Francisco

Quay, David (U.K.) 90, 120
Society of Scribes & Illuminators, London

Quinault Kossakowski, Mary
(U.S.A.) 123
Society of Scribes, New York

Raisbeck, Margery (U.K.) 80
Society of Scribes & Illuminators, London

Rees, Ieuan (U.K.) 25, 26, 31, 33, 34, 97,
103, 104, 106, 134, 135
Society of Scribes & Illuminators, London

Richard, St Clair (U.S.A.) 71
Calligraphy Space 2001, New York

Robinson, Marcy (U.S.A.) 16
Society of Scribes, New York

Rodriguez-Benitez, Guillermo
(U.S.A.) 20, 77, 149
Calligraphy Space 2001, New York

Saltz, Ina (U.S.A.) 73
Society of Scribes, New York

Sakwa, Jaqueline (U.S.A.) 110
Calligraphy Space 2001, New York

Schneider, Werner (Germany) 39, 79
Society of Scribes & Illuminators, London

Shaw, Paul (U.S.A.) 74
Society of Scribes, New York

Skelton, John (U.K.) 132, 145, 146, 147
Society of Scribes & Illuminators, London

Smith, John (U.K.) 96, 107
Society of Scribes & Illuminators, London

Thomson, George (U.K.) 83, 153
Society of Scribes & Illuminators, London

Toots, Villu (Estonia) 12, 24, 61, 100, 118
Society of Scribes & Illuminators, London

Topping, Pat (U.S.A.) 88
Society for Calligraphers, Los Angeles

Urwick, Alison (U.K.) 56, 64
Society of Scribes & Illuminators, London

Veljovic, Jovica (Yugoslavia) 14, 17, 29,
60, 63
Society of Scribes & Illuminators, London

Waters, Sheila (U.K.) 65, 66, 67
Society of Scribes & Illuminators, London

Waters, Julian (U.S.A.) 113, 114
Washington Calligraphers Guild,
Washington, DC

Weber, John (U.S.A.) 82, 94
Society of Scribes, New York

Weisberg, Patricia (U.S.A.) 25, 35
Calligraphy Space 2001, New York

Calligraphy societies

Westover, Wendy (U.K.) 16, 82
Society of Scribes & Illuminators, London

Williams, David (U.K.) 30, 64
Society of Scribes & Illuminators, London

Winkworth, Bryan (U.K.) 36
Society of Scribes & Illuminators, London

Winters, Nancy (U.K.) 91, 102
Society of Scribes & Illuminators, London

Wong, Jeanyee (U.S.A.) 27, 32
Calligraphy Space 2001, New York

Woodcock, John (U.K.) 42, 151
Society of Scribes & Illuminators, London

Zapf, Hermann (Germany) 38, 86
Society of Scribes & Illuminators, London

Calligraphy societies in USA and Canada

Calligraphers Guild
P.O. Box 304, Ashland, OR 97520

Calligraphy Guild of Pittsburgh
P.O. Box 8167, Pittsburgh, PA 15217

Capital Calligraphers
332 Atwater S, Monmouth, OR 97361

Chicago Calligraphy Collective
P.O. Box 11333, Chicago, ILL 60611

Colleagues of Calligraphy
P.O. Box 4024, St. Paul, MINN 55104

Colorado Calligraphers Guild
Cherry Creek Station, Box 6413, COLO
80206

Escribiente
P.O. Box 26718, Albuquerque, NM 87125

The Fairbank Society
4578 Hughes Road, RR3 Victoria, B.C.,
Canada V8X 3X1

Friends of Calligraphy
P.O. Box 5194, San Francisco, CA 94101

Friends of the Alphabet
P.O. Box 11764, Atlanta, Georgia 30355

Goose Quill Guild
Oregon State University, Fairbanks Hall,
Corvallis, OR 97331

Guild of Bookworkers
663 Fifth Avenue, New York City,
NY 10022

Handwriters Guild of Toronto
60 Logandale Road, Willowdale, Ontario,
Canada M2N 4H4

Houston Calligraphy Guild
c/o 1024 Willow Oaks, Pasadena,
TX 77506

Indiana Calligraphers Association
2501 Pamela Drive, New Albany,
IND 47150

Island Scribes
c/o 1000 E 98th Street, Brooklyn, NY
11236

The League of Handbinders
7513 Melrose Avenue, Los Angeles,
CA 90046

Lettering Arts Association
303 Cumberland Avenue, Asheville,
NC 28801

Lettering Arts Guild of Boston
86 Rockview Street, Jamaica Plain, MA
02130

New Orleans Calligraphers Association
6161 Marquette Place, New Orleans, LA
70118

Opulent Order of Practising Scribes
1310 West Seventh, Roswell, NM 88201

Philadelphia Calligraphers Society
P.B. Box 7174, Elkins Park, PA 19117

Phoenix Society for Calligraphy
1709 North 7th Street, Phoenix, AR
85006

San Antonio Calligraphers Guild
c/o 3118 Mindoro, San Antonio, TX
78217

St. Louis Calligraphy Guild
8541 Douglas Court, Brentwood, MO
63144

St. Petersburg Society of Scribes
c/o 2960 58th Avenue S, St. Petersburg,
FLA 33712

Society for Calligraphy & Handwriting
c/o The Factory of Visual Art, 4649
Sunnyside North, Seattle, WA 98103

Society for Calligraphy
P.O. Box 64174, Los Angeles, CA 90064

Society for Italic Handwriting, BC
Branch
P.O. Box 48390, Bentall Centre,
Vancouver, B.C., Canada V7X 1A2

Calligraphy services

Society of Scribes
P.O. Box 933, New York City, NY
10022

Tidewater Calligraphy Guild
220 Cortland Lane, Virginia Beach, VA
23452

Valley Calligraphy Guild
3241 Kevington, Eugene, OR 97405

Washington Calligraphers Guild
Box 23818, Washington, DC 20024

Western American Branch of the S.I.H.
6800 S.E. 32nd Avenue, Portland, OR
97202

The Western Reserve Calligraphers
3279 Warrensville Center Road, Shaker
Heights, Ohio 44122

Wisconsin Calligraphers' Guild
2124 Kendall Avenue, Madison, WI 53705

Calligraphy societies in Europe

The Society of Scribes & Illuminators
c/o FBCS, 43 Earlham Street, London
WC2H 9LD

The Society for Italic Handwriting
69 Arlington Road, London NW1

The Mercator Society
Gaasterland Str 96, Haarlem, Holland

Bund Deutscher Buchkunstler
6050 Offenbach am Main, Hernstrasse 81,
W. Germany

Calligraphia
5060 Bellaire Avenue, N. Hollywood,
CA 91607

Calligraphics Ink, Inc.
Crystal Underground, Arlington, VA
22202 USA

Calligraphy Design Center
1720 E 86th Street, Indianapolis, IND
46240

Calligraphy Space 2001
644 Broadway, New York City, NY
10012

Scriptorium St. Francis
1323 Cole Street, San Francisco, CA 94117